IMAGES
of America

FROM BRESLAU
TO LINDENHURST
1870 TO 1923

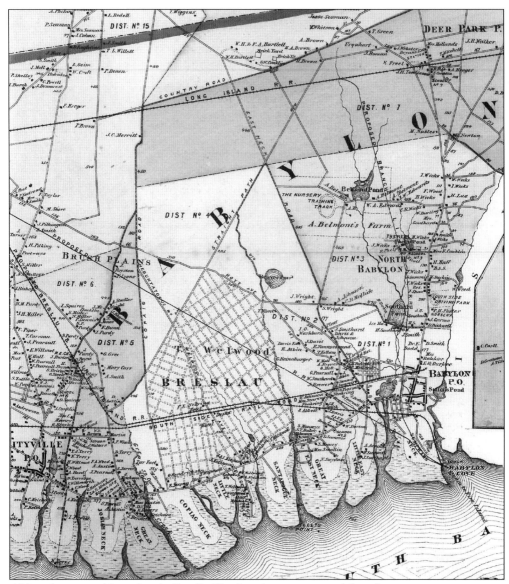

Although it was publicized as the "city" of Breslau, the community did not have its own government. It was a hamlet, or unincorporated community, governed by the town of Babylon. This 1873 map from the *Atlas of Long Island*, published by Beers, Comstock & Cline, identifies the intersecting roads and railroads of the town of Babylon and shows how the developers of Breslau created a unique street grid for their innovative new community. (Courtesy of the Town of Babylon History Museum.)

ON THE COVER: Assembled in front of Andrew Feller's hotel, this group showcases some of the activities and industries that brought fame and prosperity to the community of Breslau in the late 1800s, including a readiness for lively music and an abundance of locally produced beer and cigars. (Courtesy of the Lindenhurst Historical Society.)

IMAGES
of America

FROM BRESLAU
TO LINDENHURST
1870 TO 1923

Lindenhurst Historical Society with
Anna Jaeger and Mary Cascone

ARCADIA
PUBLISHING

Published by Arcadia Publishing
Charleston, South Carolina

Printed in the United States of America

Library of Congress Control Number: 2018945928

For all general information, please contact Arcadia Publishing:
Telephone 843-853-2070
Fax 843-853-0044
E-mail sales@arcadiapublishing.com
For customer service and orders:
Toll-Free 1-888-313-2665

Visit us on the Internet at www.arcadiapublishing.com

*In honor of past village historians Edith Bush, Lorena
Frevert, Clara Kohmann, Evelyn Ellis, and Lane Ellis for
their dedication to Breslau and Lindenhurst history.*

CONTENTS

ACKNOWLEDGMENTS

This book is the result of a collaborative project between the Lindenhurst Historical Society and the Town of Babylon History Museum to organize and preserve the historical society's photograph and postcard collections. Many thanks to the historical society board for having the foresight to protect and share these visual treasures, to Lindenhurst village historian Anna Jaeger, and to the history museum staff—Georgia Kanelous Cava, Kelly Filippone, Renee Leone, museum volunteer Samantha Parmely, and Babylon town historian Mary Cascone—for their diligent, and often monotonous, labors.

We are indebted to the preservation efforts of the historical society's supporters and contributors since its formation and to the writings and collections of the previous Lindenhurst village historians. Edith Bush was the first Lindenhurst village historian, appointed in 1941. Lorena Frevert was appointed historian in 1946 and wrote a weekly history column, "Historic Lindenhurst," in the *Lindenhurst Star* covering a wide range of local history topics. Clara Kohmann was appointed village historian in 1961, followed by Evelyn Mentz Ellis in 1969. Ellis, affectionately known in the community as "Nudy," wrote the column "Historically Yours" in the *South Bay's Neighbor* newspaper addressing many historical topics from her own experience as a lifelong Lindenhurst resident. She served 43 years as village historian until her death in 2012 and was followed by her son, Lane Ellis, for a year.

Many others have inspired and made contributions toward this project, including historical society museum director Johanna Sandy, diligent researcher John Sredniawski, the Lindenhurst Memorial Public Library, the Babylon Public Library, and Theresa Santmann of Babylon village, whose generous funding for digitization of the *South Side Signal* in 2010 has made local research much more convenient.

Images are from the collections of the Lindenhurst Historical Society except as noted. Additional images were graciously provided by Johanna Graser Sandy, the Village of Babylon Historical and Preservation Society, and the Town of Babylon History Museum.

INTRODUCTION

Today, the village of Lindenhurst has a population of approximately 26,000. It is my hometown and I am very proud of its rich, abounding history. This history can be traced back to the early 17th century, when Native Americans inhabited our South Bay shores in an area known as Neguntatogue, meaning "forsaken land." In the mid-1600s, English farmers living on Long Island's North Shore considered the "forsaken land" valuable and negotiated a contract with the indigenous people to buy the land in exchange for trinkets, tools, and gunpowder.

Huntington farmers wanted the land for its salt hay, a type of wiry grass growing abundantly along the South Shore that they used for insulating their barns and bedding their animals. They traveled along the Neguntatogue Path (now Wellwood Avenue) in their oxcarts on a jolting two-day journey to the Great South Bay. This southern portion of the town of Huntington, of which we were once part, became known as Huntington South. Some time later, around 1800, Jesse Ketcham, one of the Huntington farmers, decided to settle on the South Shore, and in 1811, he built a home on South Country Road (Montauk Highway) on the land now occupied by Narragansett Villas. Eventually, more English families began to settle in Huntington South. One farm belonged to the Van Nostrands. Other early settlers were the families of Alexander Barto and Daniel Smith. Col. Samuel Strong moved to this area in 1815.

About 1861, the fairly affluent Abby Welwood, wife of New York City businessman Thomas Welwood, began to buy acreage in Huntington South. The South Side Railroad built a line that ran from Jamaica to Babylon in 1867 and listed "Wellwood Stop" on its timetable in 1869 in honor of the area's largest landowner (the misspelling of the Welwood name on the railroad timetable remained). Soon after, Thomas Welwood and his partner Charles Schleier started a real estate project enticing prospective buyers, mostly of German descent, to buy small plots of land in their newly envisioned manufacturing city. They named their city Breslau after Charles Schleier's hometown in the German region of Prussia.

From Breslau to Lindenhurst depicts our history through a wonderful collection of community and family photographs and postcards. It tells the story of the evolution of Breslau, an entrepreneur's dream in 1870, through early Lindenhurst prior to its village incorporation in 1923. Many theories and assumptions regarding the name change of Breslau to Lindenhurst have flourished over the years. There are some folks who firmly believe it was due to the gruesome unsolved double murder of Philip and Christina Scheidweiler in 1887. Others mistakenly assume it came about because of anti-German sentiment during World War I. The latter is obviously a false assumption, since the name change occurred long before World War I. The theory that our historians deem most factual relates to a falling out between Charles Schleier and Thomas Welwood over legal entitlement to the land being sold. The wrangling in the courts for more than seven years created a fear of buying property in Breslau. The unsavory Welwood-Schleier litigation rubbed off on the reputation of Breslau. After years of debate, petitions for a name change were distributed amongst the Breslau residents. Legend tells us that a daughter of Timothy Neville, a prominent local family, suggested the name "Lindenhurst" in recognition of the admired linden trees that grew throughout the area. In 1891, the US Post Office recorded the official name change, and the Long Island Rail Road followed suit.

Life during those early years of both Breslau and Lindenhurst must have been exciting. Breslau settlers were literally ground-breakers. They were the foundation of a brand new community that was shaped by their hands, their skills, and their dreams. Men, women, and children built homes, factories, schools, and churches. Businesses of varying sorts were established. Community organizations, clubs, and societies were formed. Their German heritage gave them a very strong work ethic along with deep religious beliefs. The church and its holidays played a very important part in the life of the community. One religious observance of these German American settlers was the celebration of Pfingst, familiarly known as the day of Pentecost. The season of Pfingst played an important role in the history of Lindenhurst. It was on Pfingst Monday, June 6, 1870, that the city of Breslau was dedicated. For nearly a half-century thereafter, Pfingst Monday, and in later years Pfingst Sunday, were anniversary days celebrated not only by residents but also by hundreds of folks who came from far and wide on special excursion trains. Neighbors from nearby communities either walked or rode bicycles to join the festivities. A typical Pfingster celebration began when the excursion train pulled into the station. Local bands would be on hand to greet the visitors, and just about everyone in town gathered to join in the welcome. Buildings were decorated with pine and birch branches, and trees along Wellwood Avenue were whitewashed. The hotels held open houses with music and dancing. A carousel was set up in one of the hotel picnic parks. Local singing societies arranged concerts, and churches planned fairs. It was a day of celebration, and hard-working, amicable, and fun-loving German Americans came out for a jolly good time.

My grandparents Alexander and Anna Jaeger came to Lindenhurst from Manhattan in 1901. They were looking for a country home in a community less congested than the very busy city where they could raise their growing family. Because the Long Island Rail Road provided a direct link between Lindenhurst and New York City, where grandpa had a job with the New York Transit System, and because the community had a predominantly German population, Lindenhurst was an ideal town for the young family to plant their roots.

My dad, Edmund, born in 1903 in the house in which I presently reside, told many stories about growing up in Lindenhurst in the early 1900s. He told of the good old days when on a Sunday afternoon, for 10¢, a kid could see a serial movie at the Washington Hotel that always ended in a cliffhanger, which brought him back on the following Sunday to find out the fate of the movie's star hero. Dad told delightful tales about how tipping over an outhouse was a typical "innocent" prank performed on Halloween by him and his brothers. He also reminisced about the times my grandfather sent him to Bologna John's for a bucket of beer. There were always lots of memories.

It is my hope that all the readers who mosey through the pages of *From Breslau to Lindenhurst* will muster up some memories of a time when life was simple, less sophisticated, less complicated, and less technical—a time when, together in a community, ordinary folks did ordinary things, sometimes in extraordinary ways.

—Anna Jaeger
Lindenhurst village historian

One

BRESLAU BEGINS
DESIGN OF THE WELWOODS AND SCHLEIER

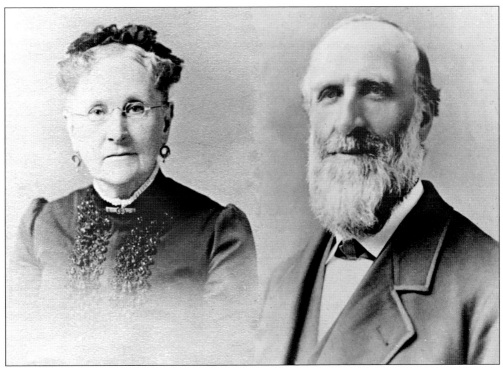

Irish immigrant Thomas Welwood married New York native Abby Cornwell in 1843. Thomas was a real estate broker and an assessor for the Internal Revenue Service. Around 1867, Abby Welwood began purchasing land surrounding the new South Side Railroad line between Amityville and Babylon. Although historical accounts credited her husband with ownership of the properties, Abby was the record owner of the lands that would become Breslau, Lindenhurst, and North Lindenhurst.

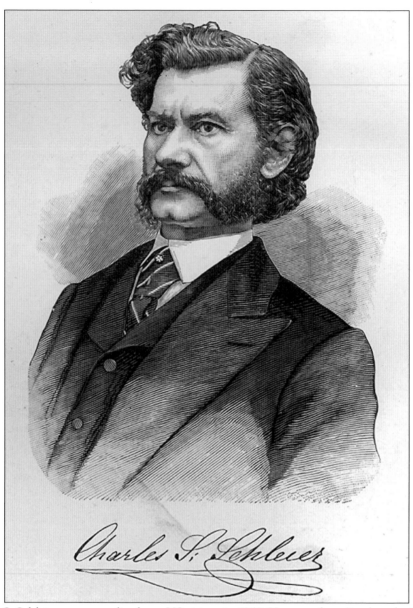

Charles S. Schleier was naturalized as a US citizen in 1860. He came from Breslau, the German name for Wroclaw, the largest city in western Poland. Breslau was part of the Kingdom of Prussia from the mid-1700s until 1871, when it became part of the German Empire. Charles owned a Brooklyn wallpaper and decorating business, was active in the local German American community, and published the Kings County edition of the weekly German-language newspaper *Wochenblatt der New-Yorker Staats-Zeitung*. In 1869, the Welwoods had their vast land holdings surveyed for building lots, each 25 feet by 100 feet. The following year, they hired Schleier as manager of their Suffolk County properties; he conceived the concept of the city of Breslau, named after his hometown, and promoted it to the German American community with which he was already familiar. Schleier opened a real estate office on Atlantic Avenue in Brooklyn, not far from his paper hanging business, and began selling hundreds of building lots, conveniently accessible by train from Brooklyn and New York City.

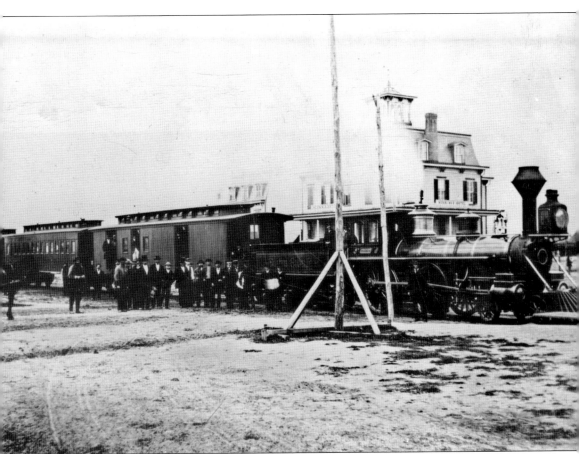

This rare glimpse of a steam locomotive emblazoned with "South Side R.R." shows Nehring's Hotel in the background. The South Side Railroad incorporated in 1860 and opened its line from Jamaica to Babylon in October 1867, passing through the open countryside that would soon be acquired by Abby and Thomas Welwood. The 1869 timetable identified the railroad stop as "Wellwood," thereby establishing the misspelling of the founders' surname, with three eastbound and four westbound trains daily. Announcing a "New German City on Long Island," the February 22, 1870, *Brooklyn Daily Eagle* stated, "A Building Association, chiefly of German workmen of New York and Brooklyn, has been formed with the object of building a town called Breslau, at Wellwood Station, on the South Side Railroad, L.I." The building association, formed by Charles Schleier, offered payment plans for prospective lot owners and home builders. Railroad access made the Breslau community possible, bringing building materials and prospective buyers from the New York metro area.

This Breslau advertisement is from "Homes on the South Side Railroad of Long Island—For New York Business Men." In April 1870, a chartered railroad excursion of two engines and 22 cars brought nearly 2,000 men, women, and children to preview the new community. Arriving at Breslau, according to the *Brooklyn Daily Eagle*, "the colonists found a large level tract of land covered with bushes and the stumps of recently felled trees. . . . Dancing platforms, covered with green pine boughs, had also been provided, and extensive arrangements made for a good time." Despite bouts of heavy rain during the excursion, the paper concluded, "All in all the route is attractive, and a brilliant future may reasonably be predicted for the entire route [of the South Side Railroad] as well as for the new City of Breslau." With great anticipation, the formal dedication of Breslau was held on June 6, 1870, reportedly attended by over 3,000 people. Welwood asserted that about 15,000 lots had already been sold. Schleier opened the dedication ceremony with some remarks in German to introduce Suffolk County judge John R. Reid of Babylon.

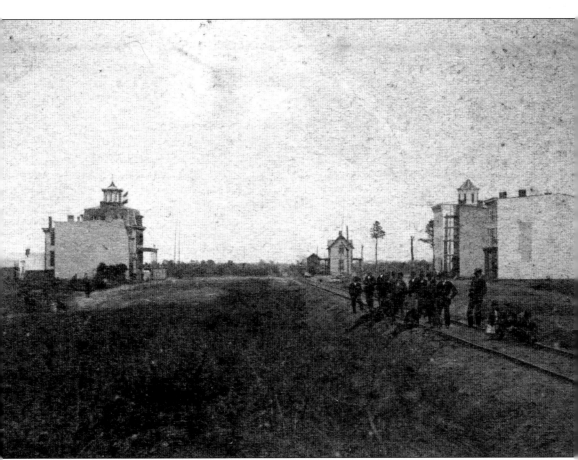

Looking east along the railroad tracks in 1871, the Wagner building and Nehring's Hotel are on the left (north) side of the railroad. At right are the depot, Gleste's Hotel, and the bank building. That year, the *South Side Signal* reported on the Easter Monday celebrations: "A special train of 10 passenger coaches brought up about 1,000 people from New York and Brooklyn, while all Long Island largely represented. The day was spent pleasantly, without any serious disturbance or drunkenness. Members of the city and Island press were most hospitably entertained at Nehring's Hotel. The great day of the year in Breslau comes off on Monday, May 29, the occasion of Breslau's anniversary and great German holiday. Over 10,000 people are expected." As Breslau grew, troubles were brewing between the Welwoods and Schleier. Just two years after their venture began, the first of many lawsuits between the partners commenced. Accusations of contract violations and disbursement of property played out in the Brooklyn courts for years, casting an unfortunate cloud over the community.

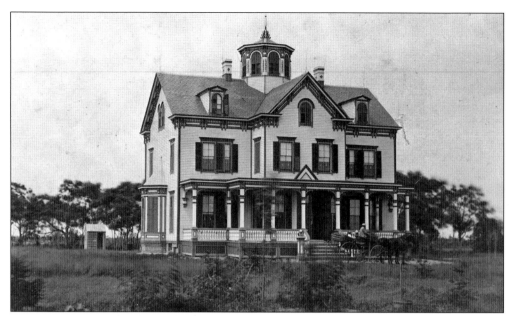

Thomas and Abby Welwood erected this charming home, named Welwood Lane, in 1871 on the north side of Montauk Highway just west of Broadway. The Welwoods, their six children, and extended family remained based in Brooklyn but spent many weeks and summers in Breslau. Thomas died in 1892 and Abby in 1903, with no mention of their passings in the newspapers of Suffolk County, where they had so greatly invested.

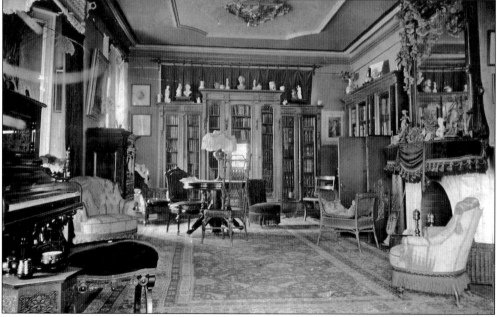

The parlor of Timothy and Johanna Neville is pictured. The Nevilles purchased the former Welwood home in 1887 and named it Warwick House; they raised seven children here. Timothy was a New York City attorney who worked for the Welwoods in selling building lots. In 1912, Johanna was elected the first president of the Suffrage Study Club of Babylon, a group of women and men who gathered to discuss, debate, and support voting rights for women.

The Schleier residence was on South Fifth Street, formerly Bismarck Avenue. After his legal and business troubles, Schleier reopened his wallpaper business and dabbled in real estate. His death prompted this commentary of his legacy in the June 11, 1887, *Signal*: "without desiring to be harsh or to speak in any but the gentlest manner of the dead, we cannot but say that few of the residents of this place will regret his decease. He had cruelly imposed upon many innocent poor persons, and he was generally held in contempt. But we mortals must not judge too harshly, and we prefer to say no more of him who has gone. On the contrary let us hope that the future will result in the prosperity of Breslau being so far advanced that the past will be but an indistinct memory. Schleier is dead; his wrong-doings, we hope, have died with him; let them be forgotten so far as is possible, and let us all unite and labor for the up-building of our own fortunes and the place in which we have cast our lot."

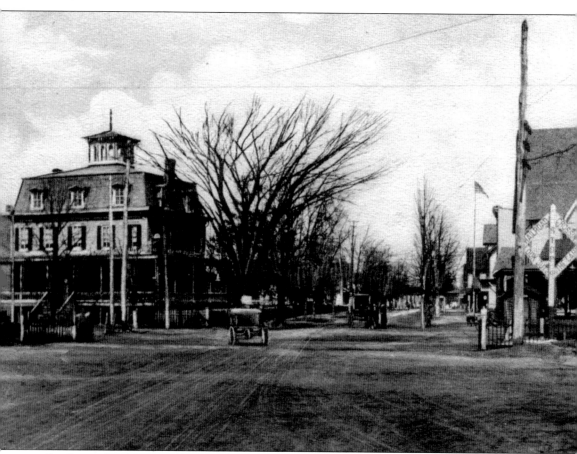

On September 24, 1870, the *Signal* reported, "Opening of Nehring's Hotel, Breslau. This fine hotel, just completed in the new City of Breslau, was thrown open to the public on Monday last, the occasion being celebrated by the proprietor keeping 'open house' for three days during which time all comers were entertained in the most hospitable manner, entirely free of charge. Large numbers from the cities and the surrounding neighborhood thronged the house, night and day; music, dancing and general merry making ruled the hours. All who came and went could not help admiring the open-handed liberality of Mr. F.E. Nehring, the pioneer in the great enterprise of building up the young city. He had already expended between $12,000 and $14,000, in buildings and improvements, and has now one of the finest hotels on the South Side. The house contains about 35 rooms, with every convenience of a first class caravansary [lodging]. It is finely located, and commands a splendid view of the Bay and surrounding country. We predict that the new Hotel will be much frequented by those seeking pleasant accommodations in the country."

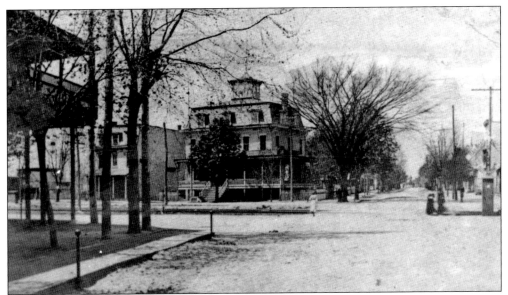

Fred Nehring, a Civil War Union veteran, died in 1874. The hotel, on the northwest corner of Wellwood and Hoffman Avenues, continued under the management of his widow, Agnes. The Nehrings' daughter, Lilly, married John Griebel. They worked alongside Agnes Nehring until her death in 1906 and then rechristened the lodging house Griebel's Hotel. After the Griebels' deaths, Edward S. Alley bought the hotel property in 1919 and converted the building for stores and apartments.

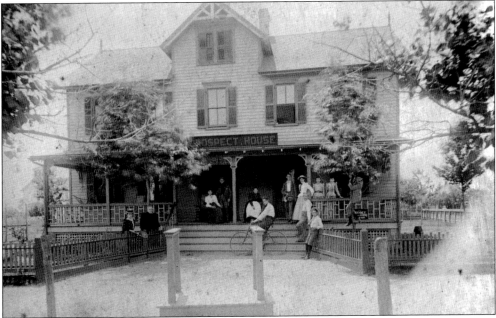

William Hirsch's Prospect House, on Wellwood Avenue near John Street, opened around 1890, one of a dozen businesses wired for electricity in 1905. Declaring that "electricity is now the popular light for the business portion of the village," the *Signal* proclaimed that the "friendly gleam" of the street lamp at the Prospect House corner "will be greatly appreciated on dark nights." Hirsch sold the hostelry to Conrad Hammerich in 1909.

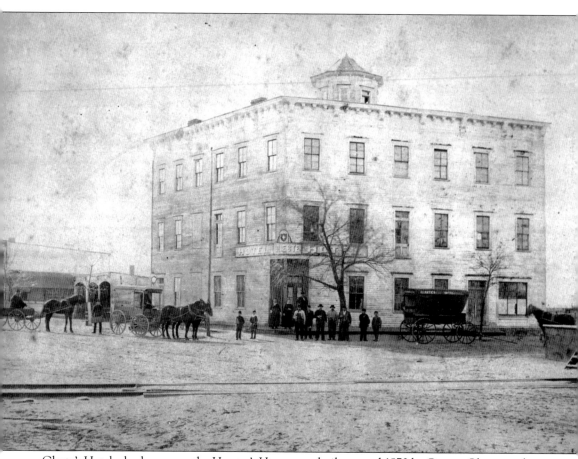

Gleste's Hotel, also known as the Hunter's Home, was built around 1870 by George Gleste on the southwest corner of Hoffman and Wellwood Avenues. He also owned property near the village docks, where guests were entertained on Sundays with a band, singing, and refreshments. The August 24, 1872, *Signal* declared, "About 700 persons came . . . from Williamsburgh, and spent the day at Gleste's Park. The day was spent very pleasantly, not the slightest disturbance occurring to mar the occasion. Whatever may be our ideas in regard to the 'observance' of the Sabbath, our German friends certainly seem to be very happy in the manner in which they spend their 'day of rest.' " From the town's formation in 1872 until the first town hall was constructed in 1917–1918, Babylon officials held meetings at various hotels. At the 1882 annual meeting, held at Gleste's Hotel, the town board passed various measures, including a resolution that $150 be appropriated to "finish the continuation of Wellwood Avenue or Neguntague Road to the bay."

George Gleste (standing, center) is pictured with his family and employees around 1894. Gleste's obituary in the August 15, 1896, *Signal* described that he "was born in Switzerland, near the German border, 65 years ago. He came to America when a young man and in 1869 or 1870 made his home here. He was the [second] man to conduct a hotel in this place. He always conducted an orderly, quiet house, and was well known to the traveling public."

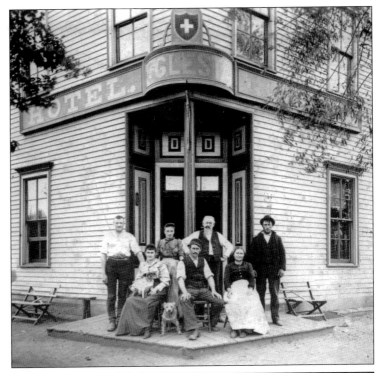

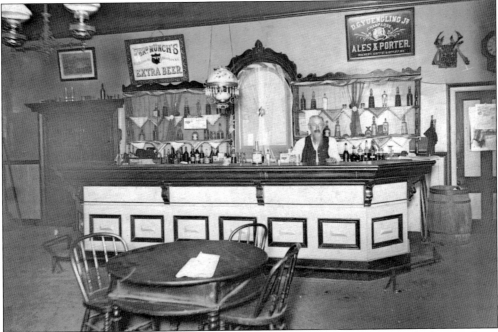

George Gleste is pictured at the hotel bar in 1894. Sometimes, merriment resulted in mayhem. In 1875, Gleste sought to remove a patron inebriated by lager beer who became quarrelsome and foul-mouthed. A scuffle broke out resulting in the man biting off part of the ear of another. Dr. E.F. Preston dressed the wounds of the injured party, and the offender was sent to the county jail without bail to await grand jury action.

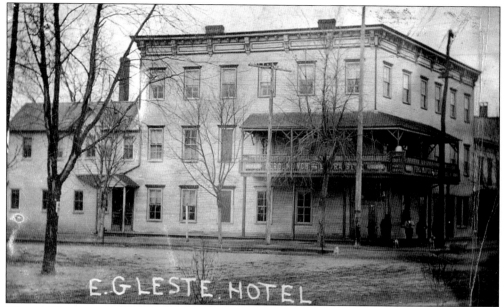

Edward Gleste succeeded his father at the hotel. The *Signal* often referred to Edward as "Mine Host," a humorous reference to a pub owner. "Mine Host Gleste is still further improving his hotel by building new stoops," the paper reported in 1900. "Mine Host Gleste's fox chase . . . drew out a good crowd and proved a successful sporting event," it noted in 1901. In 1902, the hotel added a two-lane bowling alley constructed by George Jommes.

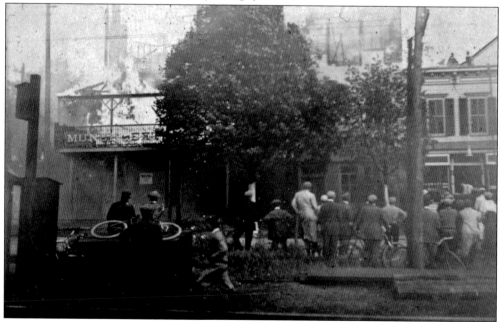

Gleste's Hotel was destroyed by fire on June 2, 1912, reportedly caused by a carelessly tossed cigarette. The local fire department fought the blaze. Under fear of the fire spreading through the downtown, alarms were sent to Babylon, Amityville, Farmingdale, and Huntington. Nearby, bank employees scurried to remove business journals, and local tenants carried out furniture and belongings. The hotel was destroyed, but the bowling alley was unscathed.

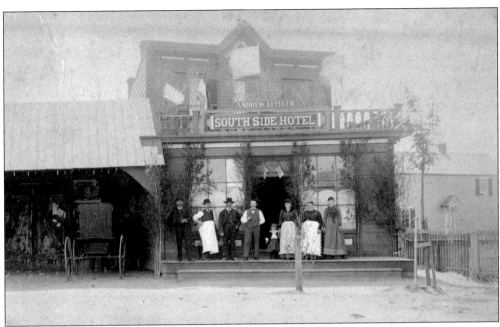

Andrew J. Feller's South Side Hotel on East Hoffman Avenue is pictured above in 1891. Andrew was the eldest son of local brewer John Feller Sr. and his wife, Margaretta. In 1894, John Sr. purchased the Central Hotel (below), on Wellwood Avenue and Dover Street, from the estate of Nicholas Heil, conveniently located near the Feller brewery. With his father, Andrew managed the Central Hotel and bowling alley, popular with the Progress Wheelmen cyclists. The *Signal* announced in 1910, "Mine Host Andrew J. Feller, of the Central Hotel, has fixed up . . . the date of his annual hog guessing"—chances were sold for guessing the animal's weight. "He has a big hog named 'Puzzler,' which he expects to keep 'the talent' guessing. The hog is a large one, and the killing will be a notable sporting event." The South Side Hotel later became Hoffman House.

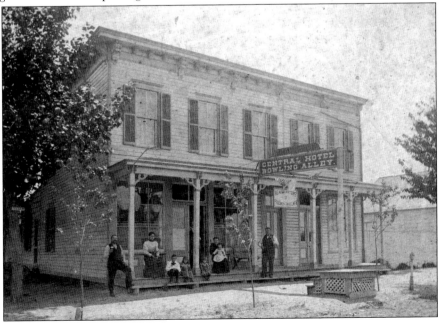

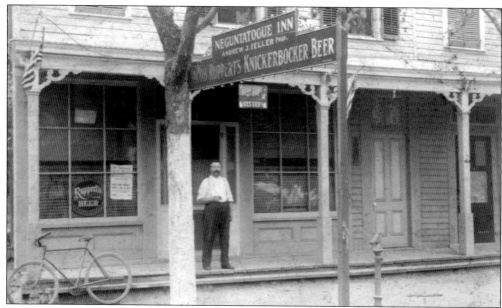

By 1908, Andrew J. Feller renamed his hotel Neguntatogue Inn. European settlers interpreted the Native American term as "forsaken land." Neguntatogue Path was the earlier name of Wellwood Avenue. A talented artist, Feller adorned the walls of his billiard and dining rooms with his artwork, including a painting of the ocean liner SS *Imperator*. Announcing an oyster supper, the *Signal* assured "Yule logs will be burned and Christmas yarns spun galore."

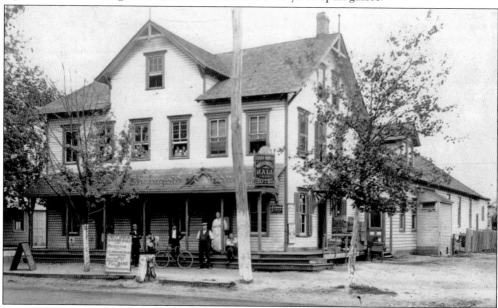

Charles Hirsch opened Washington Hall and Hotel on the southeast corner of Wellwood Avenue and Auburn Street a month after the great blizzard of March 1888. Charles's brother William owned Prospect House, and Charles's son Frank had a popular band that often performed at Washington Hall. The hall hosted parties of 700 people. On Sunday evenings, local photographer Arthur E. Parthe showcased vaudeville acts, moving pictures, and newsreels, often accompanied by local singers.

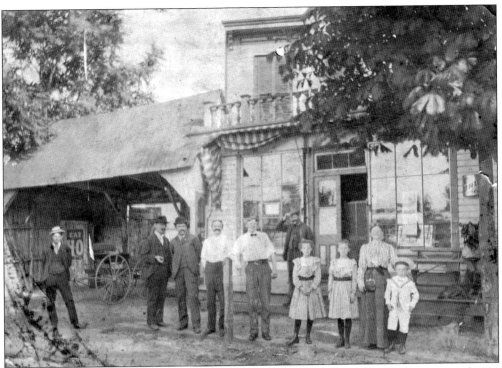

Hoffman House, formerly South Side Hotel, was operated by Frank Endler from around 1894 to 1903, then was purchased by Charles Thiele (above), who operated a stage line to the ferry docks. A few years later, Thiele sold the hotel to Charles "Bruno" Gnilka, who renovated the restaurant. The November 21, 1913, *Signal* reported, "Hoffman House was the scene . . . of a real old fashioned Hassenpfeffer, 'rabbit stew,' prepared in a manner to delight the palate. Twenty-eight partook of the feast, which is an annual affair by the local Knights of Columbus council. Musical selections and songs were given." Appealing to the sporting crowd, Gnilka advertised accommodations for gunning, fishing, and automobile parties, with meals served at all hours. A pool parlor and shoe shine stand were added in 1919. Later Hoffman House owners included John Shumaker and Christopher Hosey.

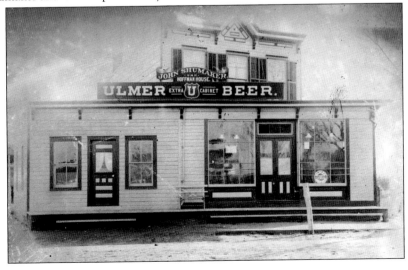

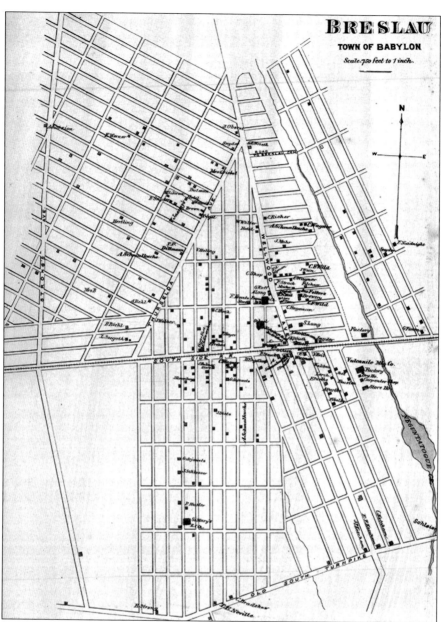

When it was founded in 1870, the city of Breslau was part of the town of Huntington. In 1872, the majority of residents in the northern and southern areas of Huntington voted to divide the town, and the town of Babylon was established. In 1923, residents voted to establish the incorporated village of Lindenhurst, governed by an elected mayor and trustees. The communities that border Lindenhurst village are hamlets governed by the town of Babylon that elect a town supervisor and councilpeople. The bordering hamlets are Copiague to the west, North Lindenhurst to the north, and West Babylon to the east. In this 1888 map of Breslau, business is concentrated in the center of the community, near the railroad. While many homes are indicated around the community, residences outside the business district are spaced far apart. The Breslau population recorded in the 1880 census was about 600. The map is from the *Atlas of the Towns of Babylon, Islip, and South Part of Brookhaven in Suffolk Co., N.Y.*, published by F.W. Beers & Co.

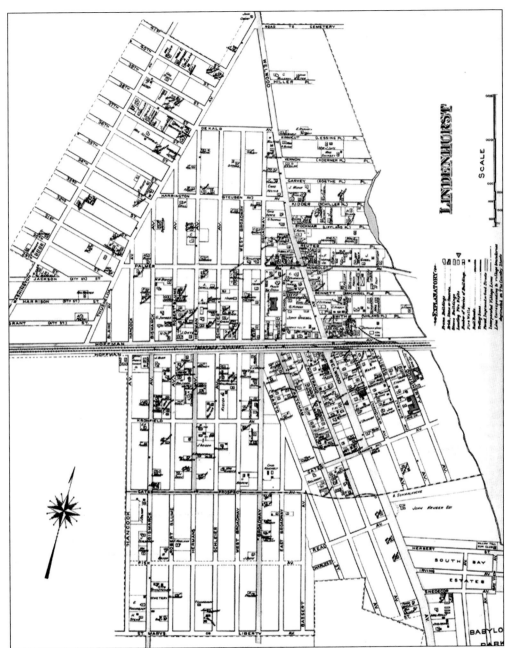

The bitter Welwood-Schleier litigation left a tarnished image on the community. In 1889, local land speculators proposed to change the name from Breslau. However, it was not until two years later that Dr. Jesse Cadawallader led a successful movement to change the community's name. Tradition says it was the doctor's wife, Alexina, the daughter of Timothy and Johanna Neville, who suggested the name Lindenhurst. Her inspiration is said to have come from a local grove of linden trees. On June 24, 1891, the community petitioned the Long Island Rail Road and the US Post Office to officially update their designations. This 1915 map of Lindenhurst, from volume one of the *Atlas of a Part of Suffolk County, Long Island, New York: South Side–Ocean Shore*, shows the exponential growth of the community. Lindenhurst's population in 1920 was 2,200.

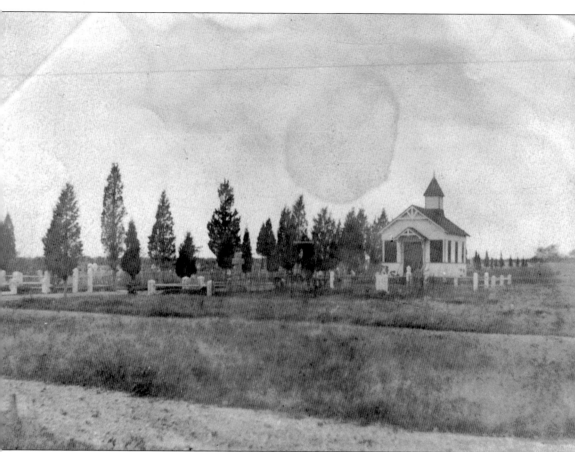

In 1874, Thomas Welwood deeded a large plot of land to the residents of Breslau, and an association for its management was formed. This plot, in the far eastern section of the village, was formally dedicated on September 18, 1875, as a cemetery. For $1, Catholic parishioners were given a deed in the name of the bishop of Brooklyn. Although the Catholic portion of the cemetery was indicated on an 1875 map, it was not used until 1895. Shortly after the cemetery incorporation, Jewish congregants petitioned for a portion of the cemetery for their sole use. In October 1876, the cemetery association sold the northeast section to the Jewish petitioners for $135. On September 15, 1887, a certificate of incorporation was filed by the Breslau Hebrew Cemetery Association. Breslau Cemetery is still an active burial ground, and the Breslau Cemetery Association is the oldest Lindenhurst organization maintaining its original Breslau name.

Two

MAKE YOURSELF AT HOME
RURAL RESIDENTIAL HOMES

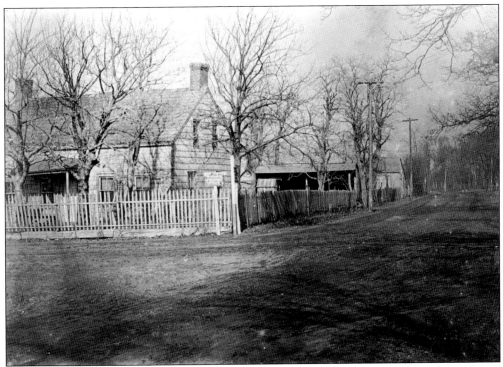

The home of Jesse and Temperance Ketcham was erected around 1780 near the northeast corner of Montauk Highway and Wellwood Avenue, reportedly the first house built in what is now Lindenhurst. Jesse served in the French and Indian War and the American Revolution. Four generations of Ketchams lived on the homestead until it was auctioned in 1901. The old house was modified by subsequent owners and eventually razed in 1956.

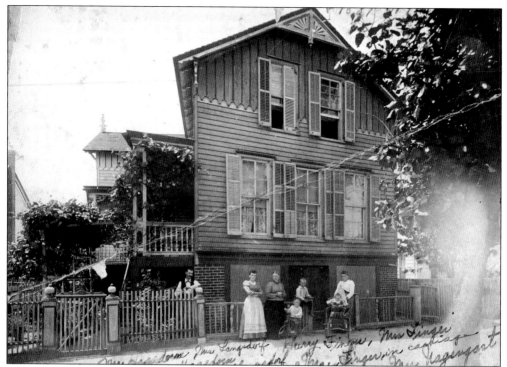

The home of Anton and Catherine Langsdorf was on the west side of Wellwood Avenue north of John Street. The October 29, 1881, *Signal* reported, "Building new houses seems to be the order of the day. Anton Langsdorf is erecting a fine new residence and store next to the [Lutheran] Evangelical Church." Known as the Langsdorf Building, the lower level housed several businesses, including Martin Boeckh's harness and upholstery shop.

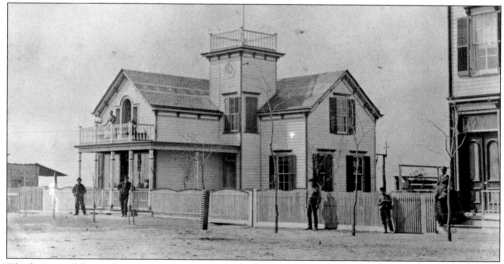

The homes of Conrad and Juliana Lerch (left) and Henry and Christina Waldau (right) on Travis Avenue are pictured around 1873. Conrad Lerch was a watchman at the original Vulcanite factory. In 1881, a rapidly spreading fire at the Waldau residence threatened adjacent buildings. Mrs. Waldau's brother, Henry Brunke, who operated a cigar factory on one of the floors, lost about 15,000 cigars and 400 pounds of tobacco in the blaze.

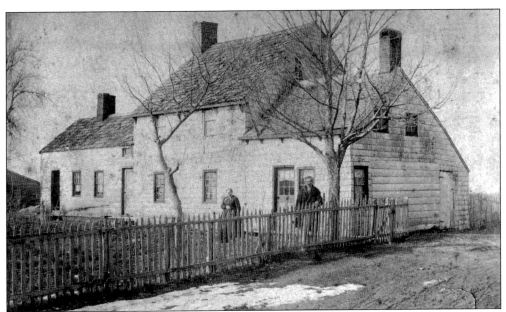

This 40-acre farm, pictured around 1900, belonged to Jared and Sarah Barto. Jared was a real estate agent, a civil engineer, and a surveyor up until his death in 1874. In 1917, aged 97, Sarah Barto was described in the *Brooklyn Daily Eagle* as the "oldest war worker on Long Island," credited for knitting sweaters, wristlets, and blankets for American soldiers fighting in France during World War I. The home was later owned by Fredrich and Fredericka Becht.

Joseph and Elizabeth Burchard are pictured at their residence on North Seventh Street, formerly Robert Blume Avenue, alongside their daughter Theresa and Elizabeth's son Edward Gleste (with motorcycle). In 1916, Joseph Burchard had a near-accident when he jumped from Edward's motorcycle as they neared the Wellwood Avenue trolley tracks. The *Signal* recalled that "Burchardt, thinking that Eddie was going to push the trolley car off the tracks, leaped clear of the machine."

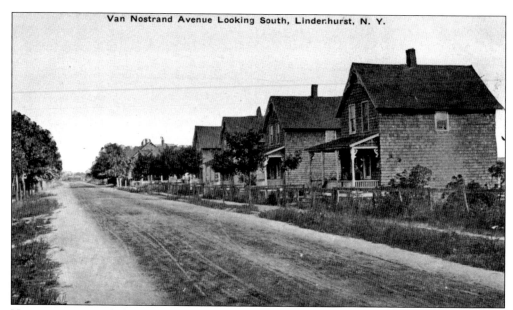

Van Nostrand Avenue Looking South, Lindenhurst, N. Y.

Homes are pictured along South First Street, formerly known as Van Nostrand Avenue. Many of the numerical streets in present Lindenhurst village had different names in the early 1900s. A 1915 map listed the following street names: Ketcham Avenue (now South Second Street), Barto Avenue (South Third Street); West Broadway (South Fourth Street), Schleier Avenue (South Fifth Street), Hermans Avenue (South Sixth Street) Robert Blume Avenue (South Seventh Street), Bismarck Avenue (South Eight Street), and Hancock Avenue (South Ninth Street).

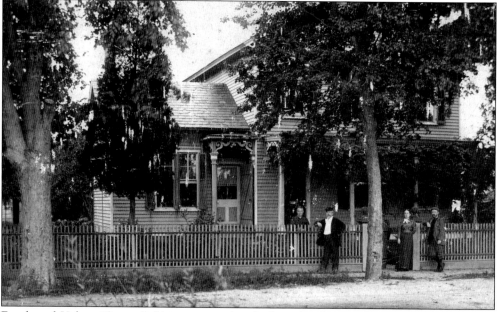

Frank and Helena Karpp (left) are pictured with their daughter and son in law Helena and Otto Burchard. Frank Karpp was a tailor, and Otto Burchard built several homes in and around Lindenhurst. In 1896, the *Signal* declared "there are a number of new wheels in town, and the outlook for enjoyment in the way of wheeling is very promising" after the purchase of automobiles by several residents, including Frank Karpp, who bought a Lovell Excell.

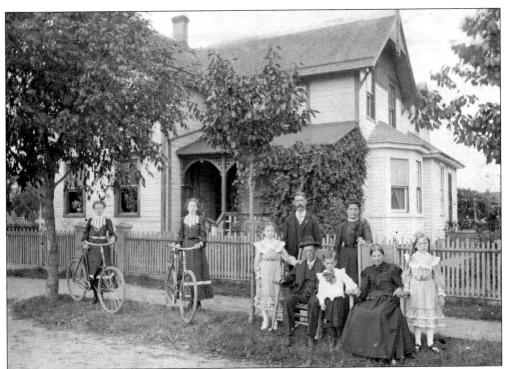

Natives of Germany, the Jommes family came to America in the 1870s, settling in Pennsylvania before relocating to Breslau. Adam and Eva Jommes, pictured with their family, built their residence on North Eighth Street, formerly Bismarck Street, in 1885. The *Signal* described the structure as "an ornament to that section." Their son, George Jommes, worked as a carpenter and builder and owned a local embroidery business.

Pictured is the North Fifth Street home of Elizabeth and Reinhardt Heger Sr. Reinhardt Jr. worked as a local German language teacher. An 1891 advertisement described two one-hour lessons per week at a cost of $2 for 20 lessons. Classes met at the millinery store of Mrs. William H. Arnold in Amityville. The Hegers' other son, Emil, had a successful career in banking and donated Heger Hall to Hofstra University in 1951.

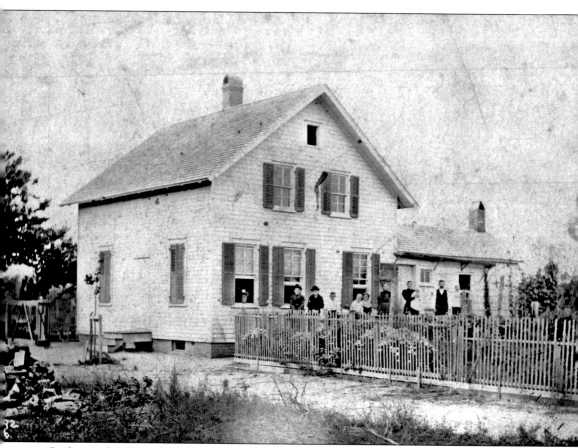

Pauline and William Kurdt Sr. are pictured on Thirty-Ninth Street in 1896. William Kurdt worked for the Vulcanite factory and met an untimely death in 1907; it was suspected that he suffered a stroke and drowned in a canal, leaving his widow and 10 children. In 1918, Pauline Kurdt was profiled in the *Signal*—"Sends Her Fourth Son Into The War." August joined the tank corps, William Jr. served several years in the Navy, and Louis enlisted in the Army. Martin was killed earlier that year in an explosion aboard the destroyer *Manley*. The Feustal-Kurdt American Legion Post was named in Martin's honor. The family profile also included daughter Pauline, married to Louis Liebl, who "also saw war service as a trained nurse doing Red Cross work in Belgium some time ago," and "younger son, Henry, is doing his patriotic bit in farm work."

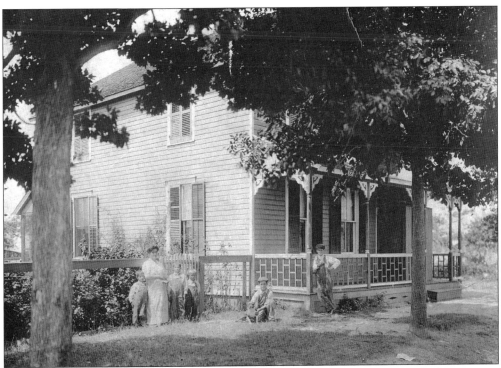

The home of Alexander and Anna Jaeger at Thusnelda Avenue, now New York Avenue, was built in 1901. Anna, pictured with five of her six sons, spearheaded the move from Manhattan because she was tired of the hustle and bustle of city life and desired a home in the countryside where she could have a garden. Alexander worked as an accountant with the New York City Transit System and commuted daily from Lindenhurst on the Long Island Rail Road. (Courtesy of the Jaeger family.)

This South Wellwood Avenue home was the summer residence of Dr. Alfred and Elizabeth Pfeiffer of Manhattan. Elizabeth Pfeiffer typically opened the house in June, resided for the summer, and closed it in October. Dr. Pfeiffer joined his family in Lindenhurst as his medical practice allowed. Announcing local doings, the *Signal* wrote, "Dr. and Mrs. A.G. Pfeiffer and family enjoyed a sail on Monday in their trim yacht *Vixen*."

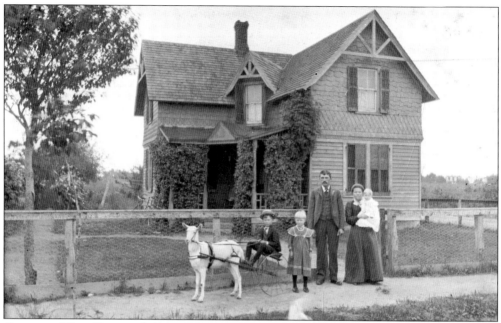

George and Kate Torns and three of their children are pictured at the family homestead around 1892. George, a German native, came to the United States as a young man, and Kate was born in New York to parents who had relocated from Germany. George worked as a nickel-plater at the Vulcanite factory in the 1910s.

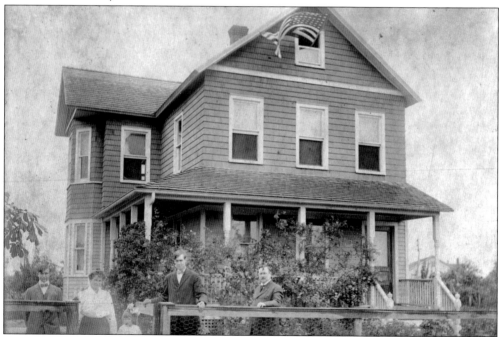

Emil and Julia Enz are pictured with three of their children (from left to right), Walter, Eleanor, and Arthur, at home on North Sixth Street (formerly Hermans Avenue) on July 5, 1915. Natives of Switzerland, the Enzes operated an embroidery shop. Emil was an active member of the Wilhelm Tell Rifle Club.

Three

GET DOWN TO BUSINESS
DOWNTOWN AND LOCAL COMMERCE

The homestead of George and Sophia Hohlbein was on South Sixth Street. George reportedly opened the first carpenter shop in Breslau in 1870. An 1882 advertisement boasted "G.J.E. Hohlbein, Manufacturer of and Dealer in Fine Furniture, Hoffman Ave., fourth door west of Nehring's Hotel . . . Upholstering in all of its branches. Mattresses made and overhauled. Furniture neatly repaired." Son Charles continued the furniture business. He is pictured with his wife, Minnie, around the 1920s.

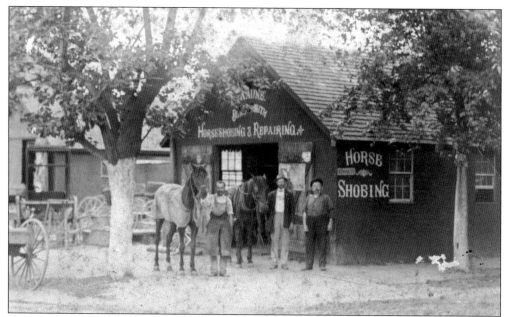

The blacksmith shop of Ernest Kaune (above) and the wheelwright shop of Frederick Minneker (below) stood side-by-side at the northwest corner of School Street and West Hoffman Avenue, both pictured around 1910. Blacksmiths and wheelwrights were important tradespeople in 19th-century communities. A blacksmith made more than just horseshoes. From iron and steel, he fashioned metal fittings for carriages and sleds, along with nails and tools, including plows, shovels, and pitchforks, needed by local farmers. As their name suggests, wheelwrights built wheels for carts and wagons, but they also made wheels for steam-powered, belt-driven machinery. These skilled craftspeople were eventually phased out by assembly line manufacturing and the increasing popularity of automobiles. Around 1918, Kaune also served as a watchman at the Wellwood Avenue railroad crossing; the trains ran at ground level, and crossing signals were manually operated.

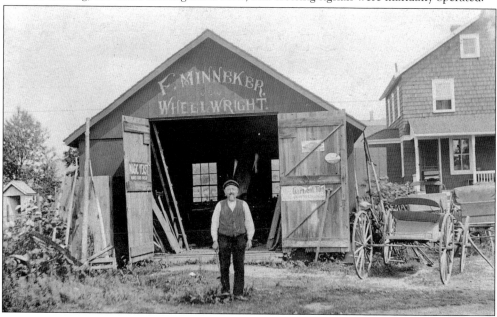

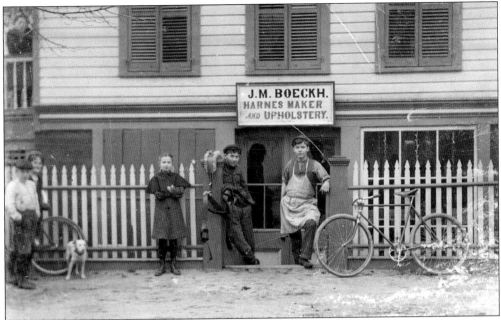

The harness and upholstery shop of Martin J. Boeckh was in the Anton Langsdorf building on North Wellwood Avenue. Boeckh emigrated from Germany as a young boy, moved to Lindenhurst at 18 around 1904, and married Johanna Tanner, a Swiss immigrant whose father, John Tanner, worked in silk embroidery. The Boeckhs operated an embroidery factory for several years until Martin's untimely death at 33 from pneumonia.

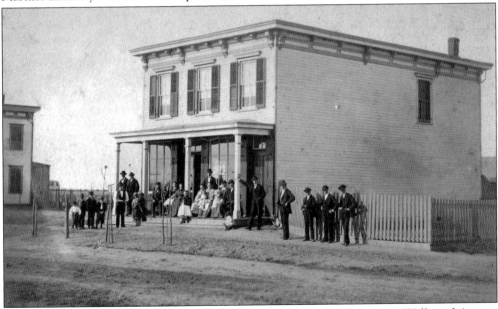

The home and store of German natives Philip and Charlotte Strack were on Wellwood Avenue between Easton and Dover Streets. In 1861, two years after his arrival in America, Philip enlisted in the Navy, and served three years during the Civil War aboard the frigate USS *Potomac*. After arriving in Breslau in 1871, he operated a hardware and dry goods store, later conducted by his daughter Louise and her husband, Charles Riehl.

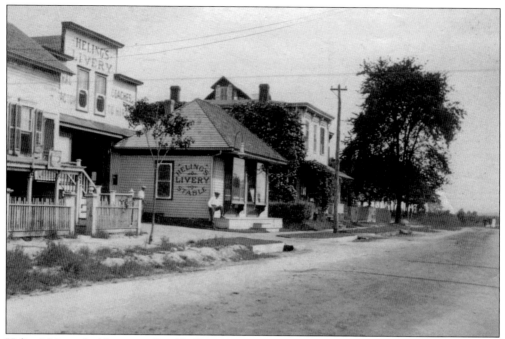

Heling's Livery Stable was on East Hoffman Avenue north of the tracks. Newspaper advertisements in 1905 boasted "Up-to-date rigs and turnouts to let at reasonable prices" and "Dealer in new and second-hand wagons, harness, whips, blankets, etc." That same year, the livery stable was one of the first establishments in the village business district fitted with electric lights.

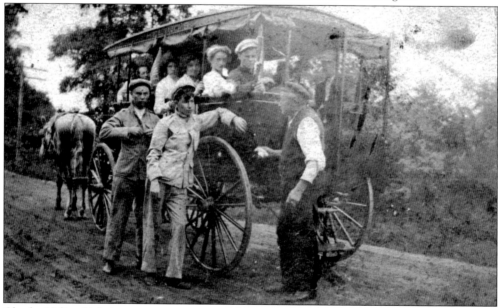

Charles Heling (right) organizes passengers on his stage wagon, another service of the livery stable. Heling served as village mayor from 1931 to 1937. Mayor Heling initiated numerous local work projects, even making several trips to Washington, DC, to provide local employment, including road improvements and clearing village-owned land. He was also elected to terms as highway superintendent for the town of Babylon.

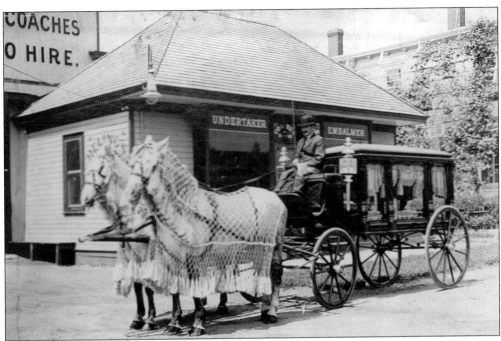

The Heling undertaking establishment was started by Valentine Heling and continued by his son Charles. It is pictured alongside the family-run livery around 1915. In November 1896, the Helings' livery and mortuary office were destroyed by fire. Undeterred, they rebuilt the office, barns, and outbuildings within a couple of months. The mortuary building was razed for construction of the Hebel-Muller Inc. cheese factory on the present site of the Suffolk County District Court.

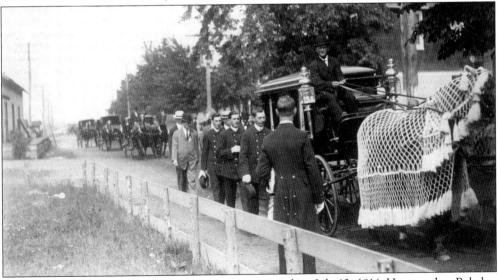

The funeral procession for Charles Warta Jr. is pictured on July 12, 1914. He served as Babylon town clerk and Lindenhurst fire chief. Following private services at Warta's home, a public ceremony at the Odd Fellows Hall was described by the *Signal* as "the largest ever in Lindenhurst," the casket "almost hidden by the many handsome floral tributes and a constant procession of friends." Wrieth's and Hirsch's bands led the funeral march to the cemetery. Charles Heling drove the funeral coach.

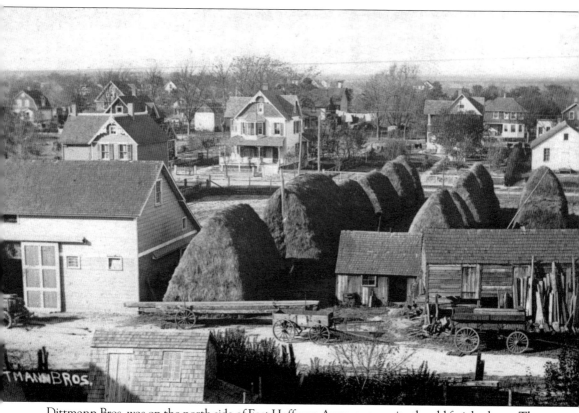

Dittmann Bros. was on the north side of East Hoffman Avenue, opposite the old freight depot. The firm moved everything from steam boilers and bank safes to entire buildings. In 1908, the *Signal* announced, "Dittmann Bros. housemovers and truckmen, are having a truck built to order at their brother's shop at Amityville, to carry from five to ten tons weight. The vehicle is so constructed that two or three horses can be harnessed abreast or as many as may be required to haul the load. The newly painted truck with the owners' three grays [horses] abreast will equal anything on the Island." The described vehicle was not motorized—the "truck" was a horse-drawn flat cart. The Dittmanns also constructed many local buildings and sold coal for heating homes. Serving the surrounding farming community, they also sold hay, hay balers, and farm wagons. By 1915, a railroad spur was laid to the Dittmann yard for the convenience of directly loading materials.

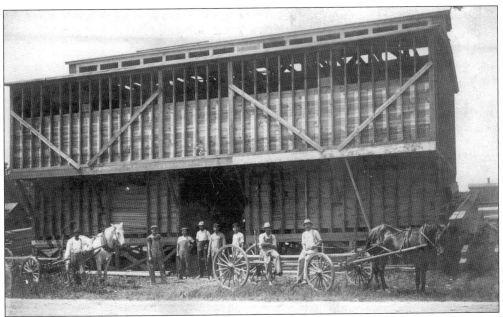

Ewald J.H. Mielke's lumber company was on West Hoffman Avenue around 1910. Also an insurance agent, Mielke advertised policies for fire, life, health, and personal accident. Ironically, the *Signal* reported Mielke's own workplace accident in 1911: "while running a machine at the yard . . . [Mielke] caught the forefinger of his left hand in the swift moving saw, severing the finger at the first joint. Mr. Mielke ran to the office of Dr. [Walter] Wellbrook."

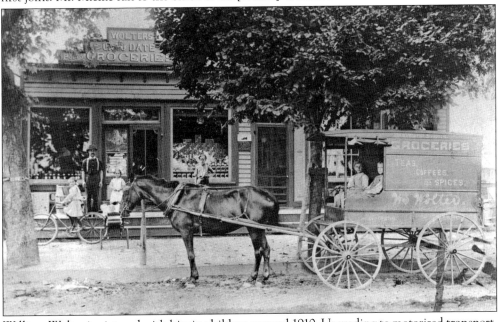

William Wolter is pictured with his six children around 1910. Upgrading to motorized transport, "Grocer William Wolter surprised his friends Saturday, when he came down the boulevard atop of a new late model six-cylinder delivery wagon direct from West street, Manhattan," according to a 1914 *Signal*. Wolter's father, German immigrant William Sr., brought the family to Breslau in the 1870s and operated the City Hall Hotel at Wellwood Avenue near Dekalb Avenue.

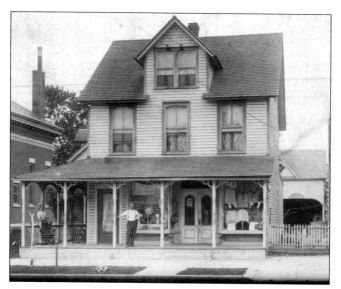

Kienle Dry Goods Store is pictured around 1908. Dry goods stores carried textiles, ready-to-wear clothing, and accessories, as displayed in the store windows, with Fred Kienle (center) and daughter Margaret (left). This store was destroyed by fire on June 20, 1914. A temporary store was established in the lower level of the National Theatre while a new brick store and living quarters were constructed at the old site and occupied that October.

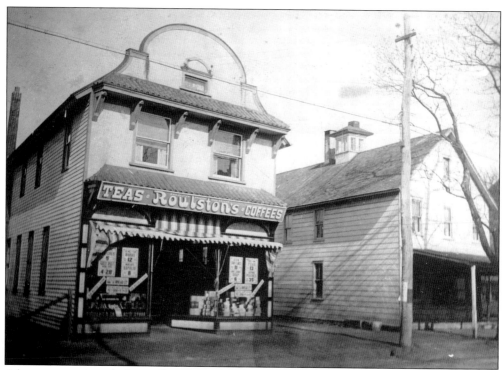

After construction of a larger Copiague schoolhouse, the old one-room school was sold at public auction for $265. Dittmann Bros. moved the schoolhouse to its Wellwood Avenue property in 1912, adding a new storefront and second story, as shown at right. It was demolished around 1938. Roulston's store, at left, was part of a New York City and Long Island grocery chain founded by Thomas H. Roulston.

Charles Wild opened his barbershop in 1902 at East Hoffman Avenue and South High Street. On busy Sunday mornings, his wife, Anna, assisted by lathering customers for their shave. A haircut and shave was 25¢; children's haircuts were 10¢. Also a local constable who could be called to duty in the middle of a haircut, Wild retired in 1922. Other early barbers included George Oelhoff, Peter Kiefer, Henry Strack, and George Pearsall.

The barbershop of Marcus J. Zeilner, at the northeast corner of School Street and West Hoffman Avenue, is pictured around 1890. His wife, Caroline, operated a candy shop next door. In 1962, long after the shop's closing, resident Emily Hirsch recalled, "The children used to sing a rhyme about shaving a pig when they passed Zeilner's Barber Shop. He used to get very angry and come out to scold them and chase them away."

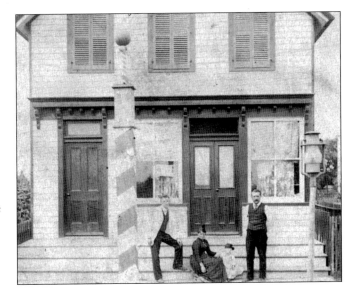

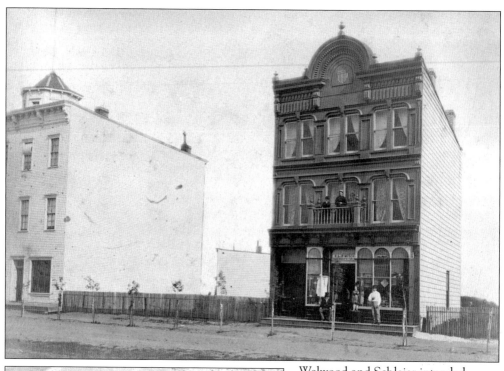

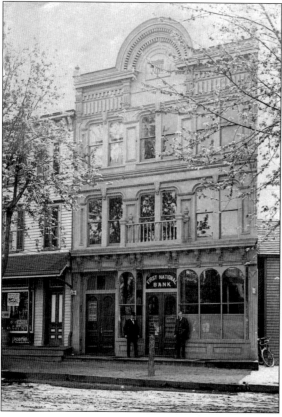

Welwood and Schleier intended Breslau to have a bank. Construction and selection of officers were completed by March 1871, but the bank did not come to fruition. Although occupied by other businesses, the building was known as "the bank building." In 1907, a group of residents established the First National Bank of Lindenhurst. The first floor of the old bank building, owned by Judge George W. Irmisch, was rented annually for $180.

Wilbur C. Abbot, Vulcanite Manufacturing Co. superintendent, was selected as the first bank president. A three-ton safe was installed, and the new East Hoffman Avenue bank opened on Monday, September 9, 1907. The first day's deposits were $10,099.48. The *Signal* reported that "Miss Lottie Irmisch was the first depositor and others lined up in rapid succession." The thriving institution soon expanded, purchasing a Wellwood Avenue plot in 1911.

The new bank opened on July 20, 1912, a brick stronghold with tile roof, granite columns, and marble interior lighted by gas and electricity. It was touted by the *Signal* as "one of two bank buildings on Long Island . . . equipped with an electric bank protection device." Its "fireproof" designation was tested by a 1914 business district fire. The *Signal* declared, "Lindenhurst Bank building acted as a fine wall saving the south side of the village."

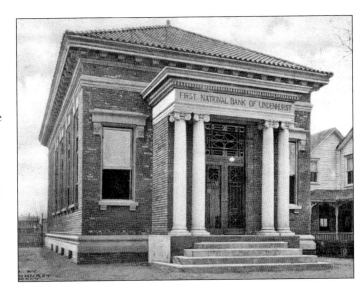

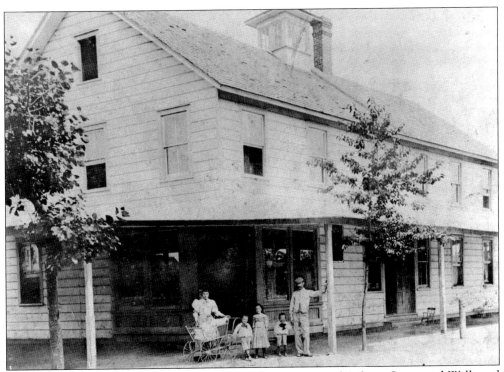

This photograph was taken in 1896 on the northeast corner of Auburn Street and Wellwood Avenue. The building was constructed by the Dittman family, natives of Breslau. Angelo and Albina Pollini sold groceries here; they are shown with their four eldest children (from left to right), Edmund (in carriage), Mario, Santina, and Felix. Louis C. Pollini recalled in 1993 that they were the first Italian family to settle in Lindenhurst.

George W. Irmisch's store was on West Hoffman Avenue. Lorena Frevert, village historian from 1946 to 1961, wrote this profile: "George W. Irmisch, a prominent public figure in this community many years ago, was born in New York City on January 13, 1862 and came as a young lad to Lindenhurst with his parents. He attended the local public schools and pursued the cigar manufacturing industry, then a thriving occupation in Lindenhurst. Later, he opened a confectionery and stationery store on West Hoffman Avenue, a short distance west of South Wellwood Avenue and built up a large newspaper trade. At age 30 he was appointed postmaster by President Grover Cleveland. He was one of the founders of the First National Bank of Lindenhurst and served as its Vice-President from its organization in 1907. A volunteer fireman for 54 years, he was a Chief Engineer of the Lindenhurst Fire Department and served as the first presiding officer of the Lindenhurst Exempt Volunteer Firemen's Association. He was school tax collector and was a member of the Board of Education for School District #4 for 24 years."

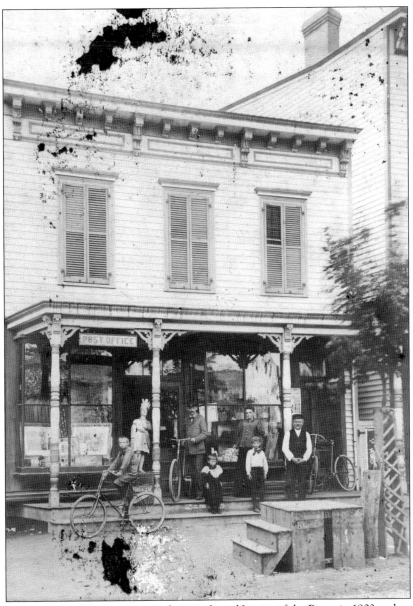

Frevert continued, "A life-long Democrat, he was elected Justice of the Peace in 1903 and represented this area on the Babylon Town Board long before Lindenhurst became an incorporated village. Because of his long tenure in this position, he was known as 'Judge Irmisch' by every man, woman and child in the community. 'Judge' Irmisch took an opposing stand when plans were being made to incorporate Lindenhurst, believing that the community could not afford to do so. However, when the village became incorporated in 1923, the Judge gave his all to promote its welfare. In 1927 he was elected President of Lindenhurst, the third man to hold that title. Also the last, because the title was changed to Mayor during his administration when Lindenhurst was officially declared a second-class village and the Village Board was increased from two to four Trustees. The triangular parcel of land located between South Broadway and South 3rd Street is known as Irmisch Historical Park. The property was given to the village in memory of the late George W. Irmisch by his descendants. Irmisch died on October 8, 1937."

Butcher Valentine Goebel opened his meat market in 1907, pictured (above left) with Ed Gleste. After he leased Kruger's icehouse in 1911, the *Signal* reported that Goebel "was fortunate in filling it the past week with ice from five to seven inches in thickness." While ice was good for food storage, it was dangerous for driving, as the paper reported: "A horse driven by Jake Boehl on Butcher Goebel's wagon fell on the icy road while turning the corner at [South Eighth Street]. . . . It was thought at first the horse was badly hurt. The wagon was slightly damaged." Goebel's Wellwood Avenue shop succumbed to the 1914 fire that destroyed the Gleste and Kienle homes, although he was reportedly able to save meat from the refrigerator. He reopened the shop but gave up the business in 1915.

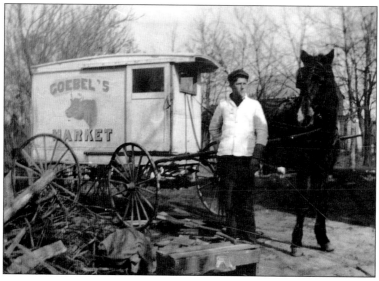

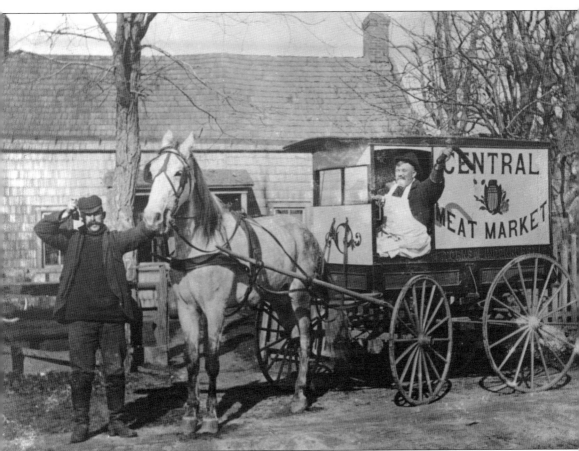

Fred Torns Jr. drives the Central Meat Market wagon around 1910. Frederick Torns Sr. emigrated from Germany around 1862 and later settled in Breslau, opening a butcher shop in 1873. Torns had learned the butchering trade in his fatherland, where his father practiced the same avocation. The *Signal* frequently bestowed praise on Fred Torns, noting in 1883 that "the butcher, has provided amply for the holiday trade. Torns knows the wants of our people." A decade later, the paper wrote, "Mr. Torns is one of the best-known businessmen in the place, and one of the most successful. If you are not acquainted with him in a business way, call at his market and purchase from his stock, and you will not fail to be pleased. If you have stock of any kind for sale, you will find a purchaser in him." Fred Torns Sr. operated his Central Meat Market for over 30 years. When he retired in 1905, Fred Jr. continued the Wellwood Avenue business.

William F. Wild (far left) is pictured at his plumbing and heating business on the northwest corner of Wellwood Avenue and John Street. He also operated a bicycle shop and post office at the site. Wild was a 53-year member of Breslau Engine Company No. 1. After his death in 1949, flags were lowered to half-mast in his memory, and the fire department shield was displayed outside headquarters for 30 days.

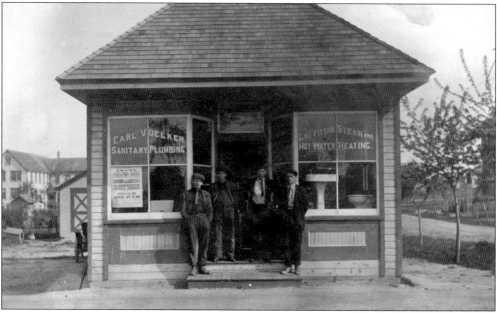

Carl Voelker built this Hoffman Avenue plumbing and heating shop for himself in 1910. The January 16, 1914, *Signal* reported, "The cold snap of Monday and Tuesday caused considerable trouble to water pipes here, which has kept boss plumber Carl Voelker and his assistants busy." Voelker sold the shop to Alfred S. Biggs and George B. Perkins in August 1914 and established a plumbing business in New York City.

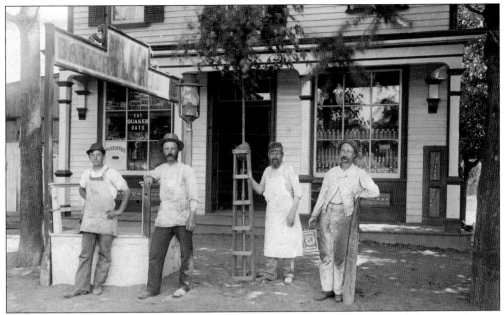

Schmalkuche's Bakery & Grocery is pictured in 1892 on West Hoffman Avenue. August Schmalkuche, second from right, was born in Braunschweig, Germany, where he learned the trade of baker. Around 1866, he immigrated to America, operating a boardinghouse before moving to Breslau in 1870. After the 1888 blizzard, Schmalkuche reportedly led a group wearing improved snowshoes across snowdrifts and woods to deliver bread to the Sisters of St. Dominic convent in North Amityville.

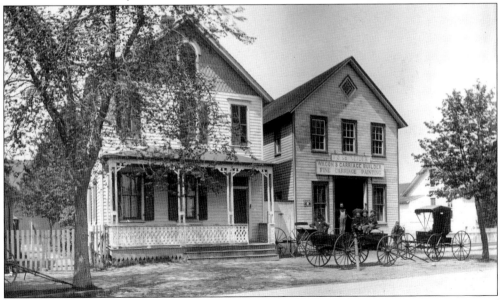

The carriage factory of Frederick O. Schneider stood on Wellwood Avenue. He built all types of wagons and carriages for residents and businesses. In 1901, the *Signal* reported construction of a substantial delivery wagon for the Sheide Bottling Co.: "It is to be a covered vehicle, intended to be drawn by two horses, and will be like all the output of Mr. Schneider's factory—first class." Schneider was also a popular musician.

The residence of Charles and Elizabeth Warta on South Wellwood Avenue is pictured around 1911. During Charles Warta's tenure as town clerk of Babylon (1911–1914), the front window was stenciled "Town Clerk's Office," and residents could transact business with him there. Soon after Warta was elected, the *Signal* alerted residents, "The Town Clerk's office is to be fitted up soon with a 3x6 table, a flat top desk, book-case, eight chairs and a rug, for the convenience of those having business at the office." From the establishment of the town of Babylon in 1872 until the construction of a permanent Babylon Town Hall in 1918, the town clerks often established offices in their homes or rented office space in local business districts. Additionally, the Babylon Town Board meetings and other local government activities were held at hotels around Babylon, with the schedule and location printed in the local newspapers.

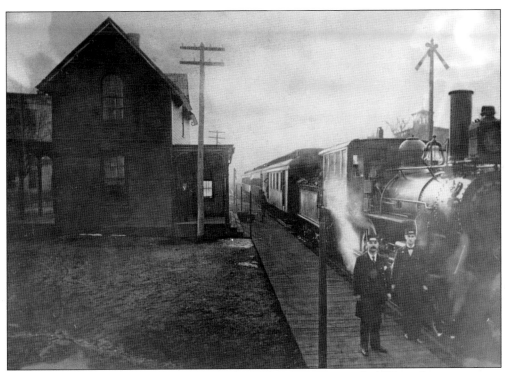

Breslau's first post office opened at the railroad depot on January 9, 1871, with station agent Gustave Gube as postmaster. The *Signal* relayed concerns about the post office during its first year of operation: "the office, which is located at the Depot, is often closed in five minutes after the arrival of trains, subjecting parties calling for mail too much annoyance." Pictured here in 1897 are conductor Philip Birchell of Babylon and William Laurence of Breslau.

In 1879, Ferdinand Beschott was appointed postmaster, and the post office was eventually relocated to the lower level of his residence on East Hoffman Avenue (pictured). Postmaster Beschott served until July 30, 1885. As he began to sort the evening mail that day, Beschott died suddenly of heart failure. Charles Wagner succeeded Beschott and moved the post office to his West Hoffman Avenue residence, next to Nehring's Hotel.

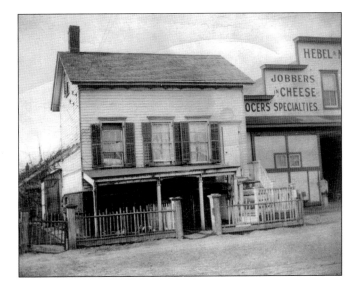

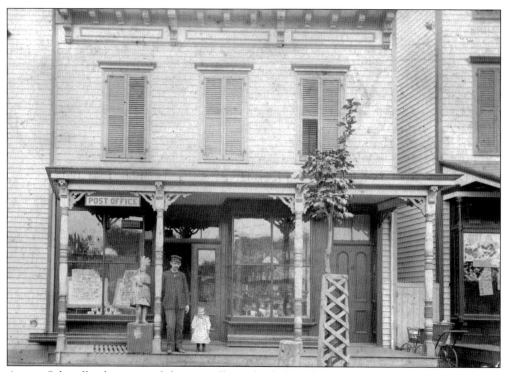

August Schmalkuche operated the post office at his bakery from 1889 to 1893, during which time the name "Lindenhurst" was adopted. George W. Irmisch became postmaster in December 1893, and the post office was established at his West Hoffman Avenue cigar shop (pictured). The *Signal* reported, "He has a new outfit, consisting of 112 call boxes and eight lock boxes. It is a very neat outfit, and Mr. Irmsich is quite proud of it."

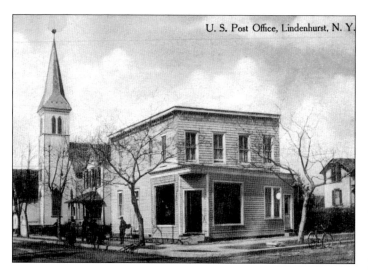

Frederick Torns Sr. became postmaster in 1897, operating first from his butcher shop and later at the home of his son George. William F. Wild was appointed postmaster in 1913, using his bicycle shop (pictured) at the northwest corner of West John Street and Wellwood Avenue as the post office. Wild held the position until 1922, serving nearly twice as long as the local postmasters before him.

Clarence E. Hirsch was postmaster from 1922 to 1929, conducting the post office from his South Wellwood Avenue store until this brick post office was opened in 1928 just north of the Catholic church. In 1929, Herbert Torns, grandson of previous postmaster Frederick Torns Sr., succeeded Hirsch. Herbert initiated the campaign for home mail delivery and served on a commission to rename many local streets and assign house numbers to facilitate the delivery service.

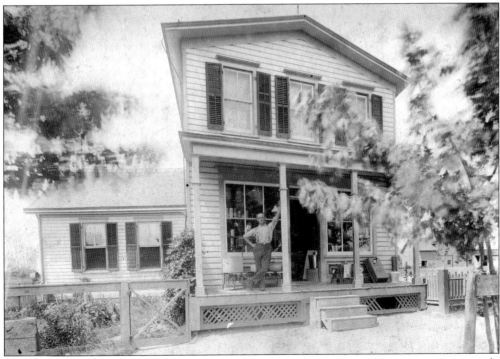

Swiss natives Henry and Rosa Ramsauer came to Breslau around 1870. Henry was a tinsmith, plumber, and builder. He is pictured at his Wellwood Avenue shop around 1890. After his death, Rosa operated a hardware store. Her 1918 obituary in the *Signal* recalled, "Mrs. Ramsauer offered her store for a meeting room . . . [and] took an active part in the Red Cross work often sitting with the members knitting articles for the boys at the front."

Around 1917, Swiss immigrants John and Marie Knecht moved to Lindenhurst from Ronkonkoma and opened a shoe repair shop in the Wagner Building on West Hoffman Avenue. John Knecht was a member of the Frohsinn Mannerchor (translated as "men's cheerful choir") and volunteered as its director of publicity.

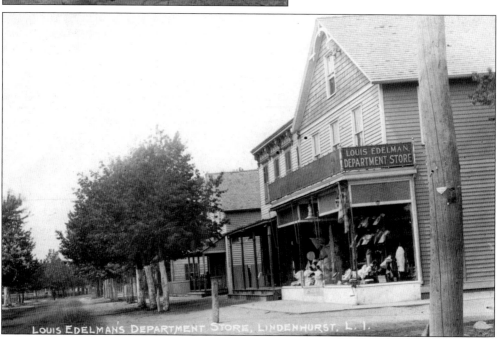

Louis Edelman's clothing and department store was on the northeast corner of Wellwood Avenue and East John Street. In 1913, Edelman erected a two-story building behind the store for an embroidery factory. The addition of Edelman's four machines reportedly brought the total number of embroidery machines in the village to nearly 100. Edelman purchased Louis Liebl's embroidery plant in 1916.

Ground breaking for Edward Gleste's National Theatre on Wellwood Avenue took place on October 13, 1913. Presented with a spade by contractor George Weierter, Edward's wife, Flora Gnilka Gleste (second from left), "removed the first earth, when a number of friends extended to Mine Host Gleste all kinds of good luck in the new venture," reported the *Signal*. The grand opening took place on December 27, 1913, with two shows featuring music by Wreith's orchestra.

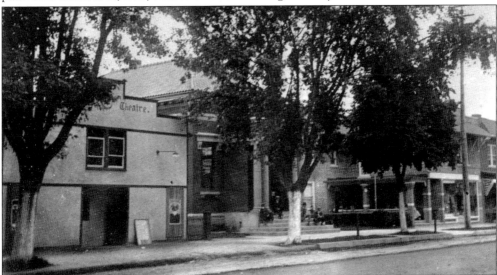

The west side of Wellwood Avenue is pictured on July 5, 1915, showing the National Theatre, First National Bank, Kienle's Dry Goods Store, and Lindenhurst Candy Kitchen. The whitewashed tree trunks were part of the recent Pfingst celebration. During World War I, the National Theatre hosted shows benefiting the local Red Cross. The entertainment hall was also the site of local Democratic rallies, as Republicans typically met at Washington Hall.

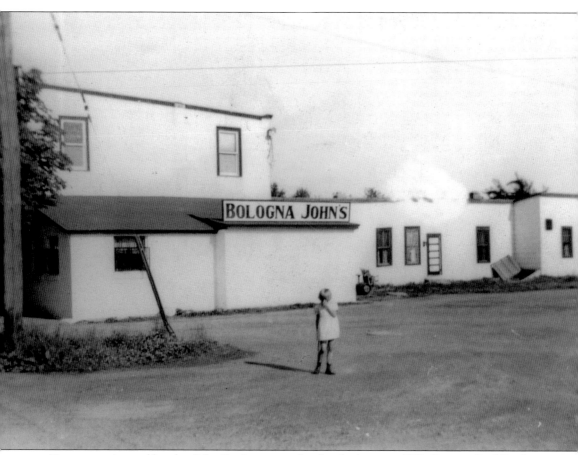

German native and butcher John Benkert moved to Lindenhurst in 1923. Stepson Paul Benkert recalled, "The people would ask for bologna sandwiches, instead my father would take a plate and put all sorts of bologna, bread and pickles on it and served it that way—that is how the people named the place Bologna John's." During Prohibition, Bologna John's was a popular speakeasy. Similar to other Long Island establishments, Bologna John's was periodically raided by federal agents. In a 1931 bust, the bartender was held on $2,000 bail and charged with sale and possession of liquor, and agents "seized 80 half-barrels of alleged beer . . . four of the barrels were on tap, 36 on ice and 40 stored in another building," as reported by the *Brooklyn Daily Eagle*. After John's death in 1932, his widow, Anna, and sons Paul and John continued the Thirty-Eighth Street restaurant.

Four

INDUSTRIAL STRENGTH
MANUFACTURING FIRMS AND ENTERPRISES

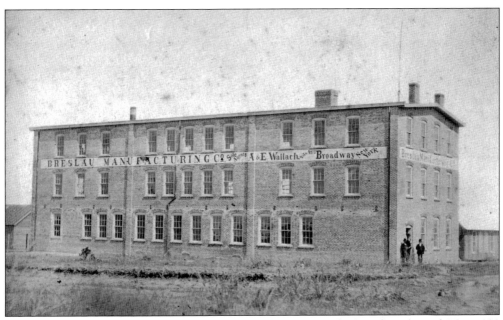

The Breslau Manufacturing Company opened on July 29, 1872. The *Signal* proclaimed, "Over 100 different articles are manufactured from saw dust, by patent process, including picture frames, match boxes, clocks, jewelry and ornaments of different kinds. This will be a great benefit to Breslau, and add materially to the welfare of the place."

E. G. TRASEL,
Novelty Papier Maché Works.
FACTORY AT
Breslau, Long Island,
F. MARQUARD, Superintendent.

Papier Maché, Household Ware, Wash Basins, Water Pitchers, Office Spittoons, Cuspadores, Soap Dishes, Brush Holders Chambers, Pails, Milkpans, Chamber Sets, Picture Frames of every description, first-class **Black Walnut Furniture, Cornices, &c., &c.,** Carved and Gilt, made to order.

DECORATING, PAINTING, GILTING & REPAIRING of FINE FURNITURE, CABINETSWARE AND FANCY GOODS, by EXPERIENCED WORKMEN.

Office and Salesroom 45 Murray St. N. Y.

J. ZIEGLER, UPHOLSTERER & DECORATOR,
FURNITURE, MATTRESSES, &c., MADE TO ORDER & REPAIRED.

Hanging of Curtains, Shades, laying and fitting of carpets, and all work in this line promptly attended to. Orders to be sent to the office of the NOVELTY PAPIER MACHE WORKS, BRESLAU, L. I.

Rags and Paper Stock Bought by the Novelty Papier Maché Works, Breslau, L. I.

PEDLARS SUPPLIED.

A patent for vulcanized rubber was filed in 1869 by Frank Marquard of Massachusetts. His composition consisted of sawdust, sulphur, starch, color, and water, which was mixed, dried, and pulverized. Heated to 300 degrees, the molded compound hardened, or vulcanized. Once lacquered, the material was water resistant and suitable for wash basins, spittoons, pails, and picture frames. The Breslau Manufacturing Company was commonly known as the papier-mâché factory or the Novelty Papier Maché Works, as depicted in this 1875 advertisement.

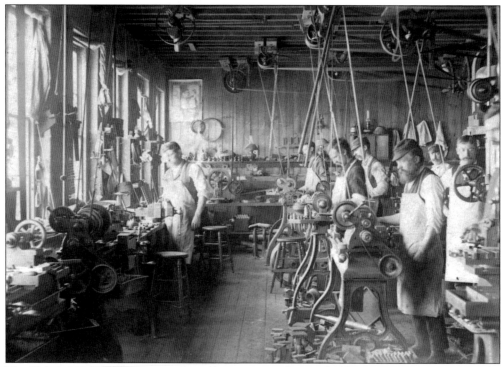

The Vulcanite Manufacturing machine shop is pictured around 1890. An important factor in the development of Breslau was the creation of local jobs. Encouraging business growth, community developers offered free land to businesses that agreed to build or relocate operations in Breslau. In 1880, the Vulcanized Horn and Rubber Button Manufacturing Company of Massachusetts acquired the papier-mâché factory and moved its operations to the Breslau factory, employing 200 boys, girls, men, and women.

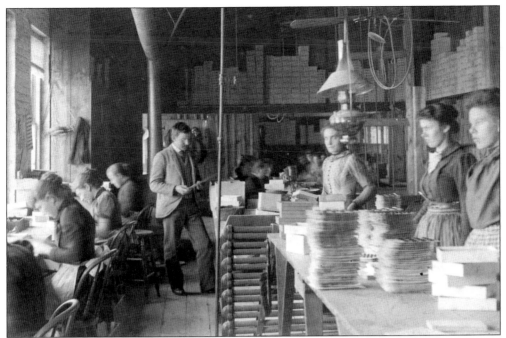

Around 1890, the Vulcanite Manufacturing Company sewing room (above) was where products were sewn onto display cards, and the box shop (below) was where finished items were packed for sale and shipment. Accompanying the factory's settlement in Breslau, a Massachusetts merchant, Wilbur C. Abbot, relocated his family to Babylon and was appointed superintendent of the Vulcanite factory. Active in community and business affairs in Babylon and Lindenhurst, Abbot held the position of superintendent until his retirement in 1936. In addition to producing a variety of buttons and sewing notions, the factory began fabricating electric insulators for the Edison Electric Light Company in 1888. The factory itself was not equipped with electric lights until the end of 1892, when the *Signal* proclaimed that the factory "presents a brilliant appearance, after nightfall." Factory work was hazardous, and many work accidents were reported.

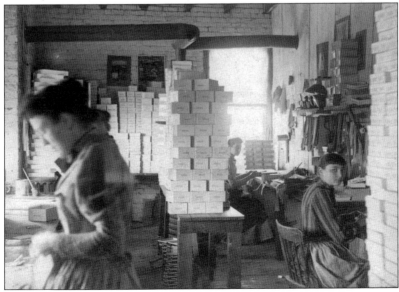

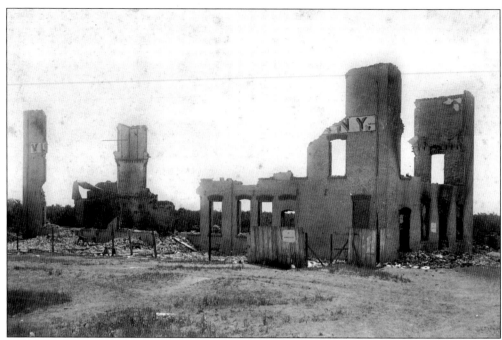

On Sunday, June 2, 1895, the day before the community was poised to celebrate Pfingst Monday and the 25th anniversary of Breslau, the Vulcanite factory was completely destroyed by a fire that originated in the drying room around 11:30 a.m. A telegram wired to Babylon brought reinforcements by noon, and 200 firemen battled the blaze, which rendered hundreds of residents unemployed. The *Brooklyn Daily Eagle* recalled, "The whole interior of the structure was soon a mass of roaring flame fed by the highly inflammable material used in the manufacture of the goods turned out by the company. As the floors gave way section by section the heavy machines fell through the cellar with a crash. Everything capable of being burned was destroyed in about four hours . . . nothing left but a few sections of brick wall and three chimneys."

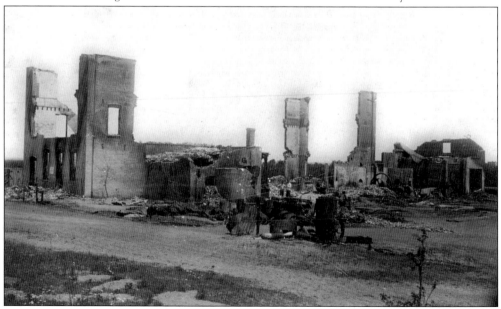

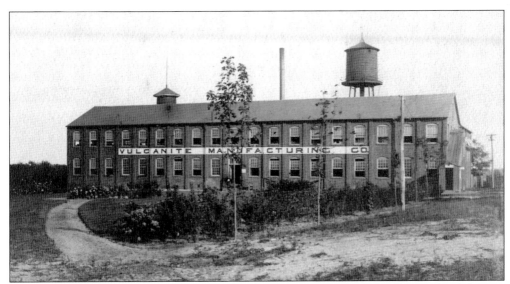

Within two weeks of the fire, Vulcanite Manufacturing made plans to build a new brick factory, "nearly fireproof as possible," according to the *Signal*. Some employees took up work at a nearby temporary factory, while others worked to clear the site. The *Signal* reported that the new factory (above) was "equipped with all modern appliances for convenience and economy, including electrical power, electric lights, hydraulic elevators, heating by exhaust steam from the engine and pumps, fire proof vaults for dies and tools [which] will enable them to fill their orders more promptly and satisfactorily than before." In 1870, Charles Hirsch Sr. blew the first whistle for the Breslau Manufacturing Company; 25 years later, his son Charles Jr. blew the first whistle for the new Vulcanite factory on October 22, 1895. Below, a parade float showcases some of the safety pins and novelties produced by the Vulcanite company.

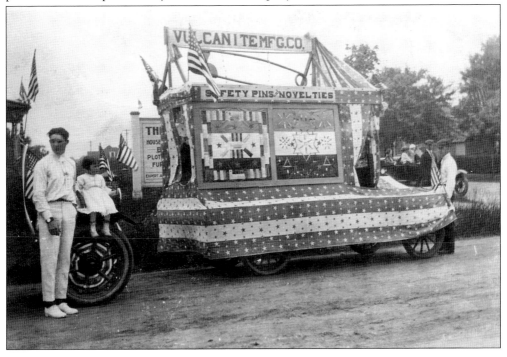

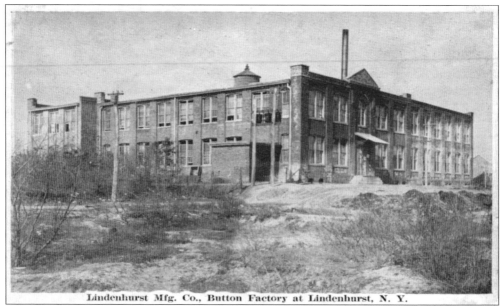

Lindenhurst Mfg. Co., Button Factory at Lindenhurst, N. Y.

The Lindenhurst Manufacturing Company formed in 1901, operating first from a frame building purchased from Frederick Henke on Travis Avenue. It moved into a new brick factory known as the Button Shop on Smith Street in 1909. The factory produced buttons from animal hooves and horns. When the Vulcanite factory discontinued making buttons in 1904, Lindenhurst Manufacturing purchased its dies and machines. Automatic machines were installed in the late 1920s.

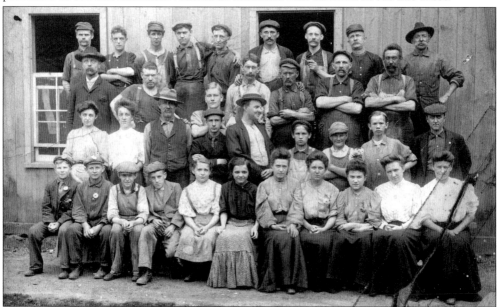

Employees of Lindenhurst Manufacturing Company are pictured around 1907. Around 1920, the factory extended employment for work from home. Wooden boxes with 25 to 50 gross of buttons were delivered to home workers, who strung groups of buttons on a pin and rolled them in paper, earning 2¢ per gross. Home workers, mainly women, were also assigned to hand sort buttons, separating defects, odd sizes, and ones to be polished, and could process 14,000 to 20,000 buttons per day.

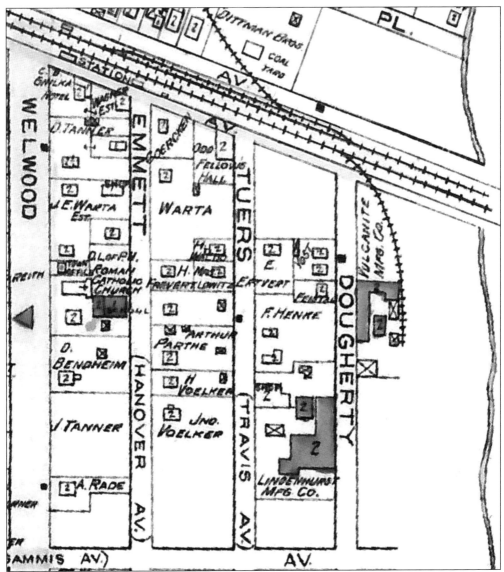

This 1915 map shows the neighboring Vulcanite Manufacturing Company and Lindenhurst Manufacturing Company on either side of South Smith Street, formerly Dougherty Avenue. The factories were points of pride for the community, not only for the workmanship of their products but also because the facilities represented the growth of the community and success as a modern town that combined residential living and industrial employment. The Lindenhurst Manufacturing Company closed its doors in 1971, and the building was destroyed by fire in 1983. The Vulcanite Manufacturing Company went out of business in 1937. The following year, the building was acquired by Lakeville Industries, which started manufacturing kitchen and bathroom cabinets in 1935 and continues to this day.

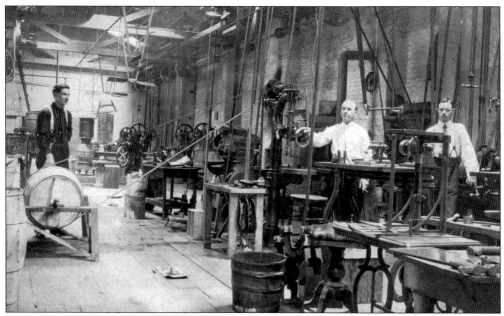

The embroidery shop of Jennie Liebl and son Louis was built in 1911. Agnes Nehring is credited with introducing Swiss embroidery to Lindenhurst. In 1886, she purchased a machine using 208 needles for openwork embroidery and 70 for slipper work. Nehring engaged an experienced machine operator, along with several assistants, to fulfill orders received from New York City shops. A myriad of embroidery shops soon followed, many owned and operated by women.

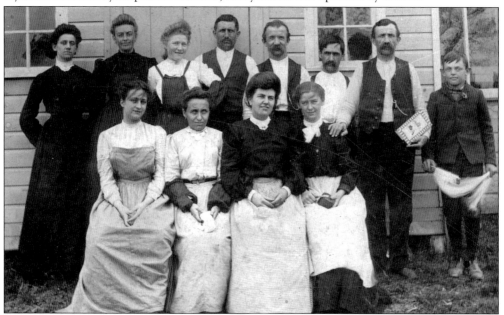

Workers are pictured at John Tanner's embroidery shop on South High Street. In 1906, the *Signal* described the Swiss native's industriousness: "As an indication of what thrift, industry and frugality will accomplish it is well to recall the fact Mr. Tanner came here less than a decade ago, worked at his trade in one of the local embroidery works for a year or two, saved his money, married, purchased a pleasant home, purchased an embroidery machine."

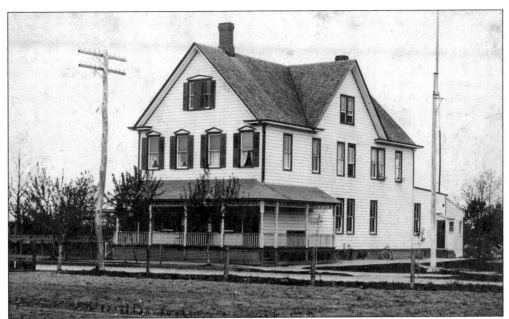

Charles Weierter's embroidery shop (above) was on the north side of West John Street; his workers are pictured below in front of the shop around 1905. Weierter's shop was among those profiled in the *Brooklyn Daily Eagle's* 1903 summary of Lindenhurst manufacturing businesses, "Manufacturing Plants May Aid Village Growth—They Need Not Necessarily Prove Unsightly or Interfere with Other Interests." Weierter stated that he learned the trade from a friend of his father, and employed about 35 people during the busy sample season. Embroidery work was described as "clean" and well-paying. Skilled stitchers earned $15 to $20 weekly, while less skilled girls earned about $5. Emphasizing the wholesomeness of the local industry, readers were assured, "all the factories for embroidering are located in substantial home-like buildings and the help comes from the respected families."

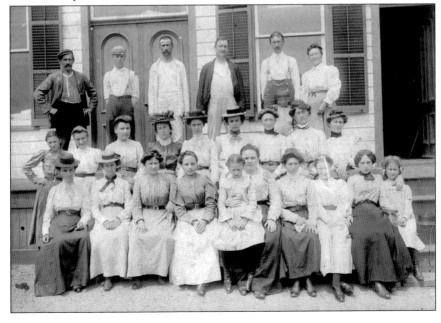

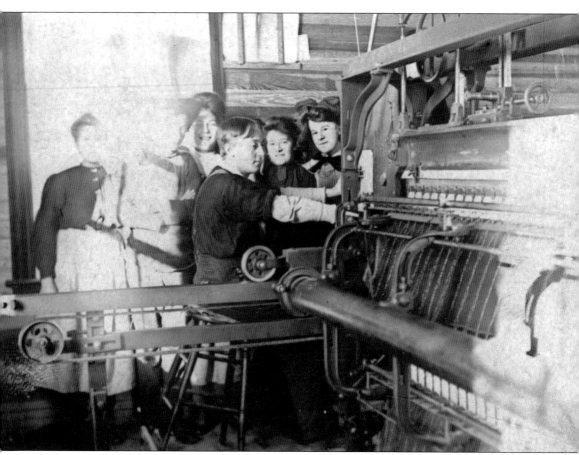

Working the embroidery machine required physical endurance and was typically performed by men. The *Eagle* described the work: "The operator sits at one end of the machine on a stool, leaning slightly forward. There are two foot treadles [levers], one for each set of needles on the machine. Before him is the pattern to be worked, an initial or border. The operator or stitcher uses a tracing needle with his left hand while his right has to grasp the crank connected with the set of cogs, governing the needle and thread carriage. Thus, in operating the machine, the stitcher has his hands and feet employed, his eyes and brain. He must watch the tracing of the pattern, release the needle carriage at the proper time, see that too much tension is not given the stitching and observe that no threads break. The pattern placed before the stitcher is six times larger than when worked, being reduced from the tracer by a pantograph. In border work, a variety of colored silk or just plain white can be used. . . . Some patterns require an entire day to work."

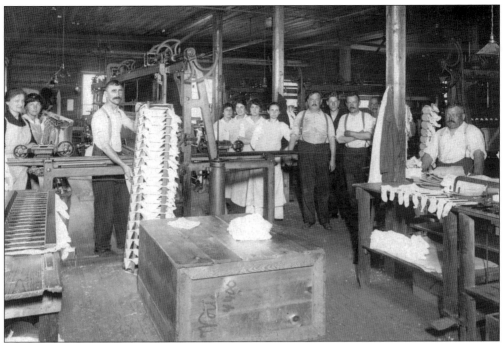

Above is the interior of Jacob Leemann's embroidery shop in 1915. Below, Leeman's building on South Wellwood Avenue was originally built around 1871 for William Gauckler, the first Babylon justice of the peace from Breslau. In 1912, New York amended the labor law, limiting women and minors to a nine-hour work day and 54 hours per week. The new work hours caused tension in some stitching shops. About 20 young women went on strike. They asserted that they had completed the same amount of work in nine hours that they had done in the old 10-hour days, and they wanted to be compensated at the rate of a 10-hour work shift. The workers were losing an hour's pay each day. The strikers lost their fight, returning to work the following week at the lower pay rate.

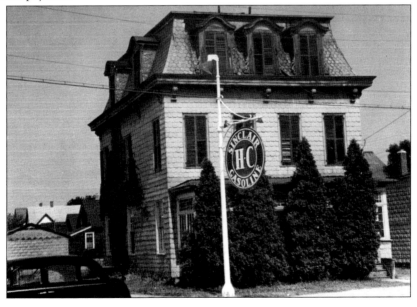

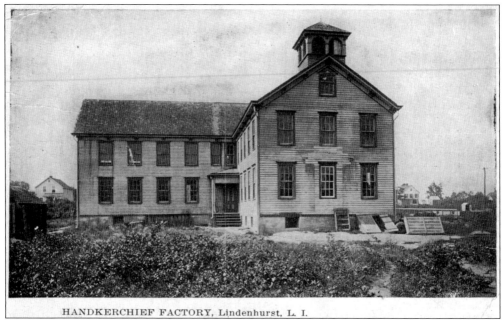

HANDKERCHIEF FACTORY, Lindenhurst, L. I.

After a new brick school was opened in 1911, Dittmann Bros. moved the old wooden school facing Fourth Street for use by the Lindenhurst Shoe Company. The shoe factory was short-lived, closing in 1913, not long after violations of child labor laws. The Long Island Embroidery Company quickly took occupancy, and the building was known as the Handkerchief Factory. In 1913, Lindenhurst had 80 embroidery machines operating in 23 factories.

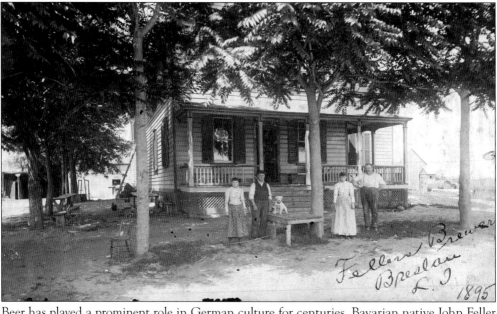

Beer has played a prominent role in German culture for centuries. Bavarian native John Feller was not the first Breslau brewer, but became well-known. He is pictured with his family at their East John Street residence in 1895. In 1881, Feller enlarged his establishment, and the *Signal* proclaimed, "Feller's lager beer has already quite a reputation and his new vaults will enable him to brew an article which even the fastidious will praise."

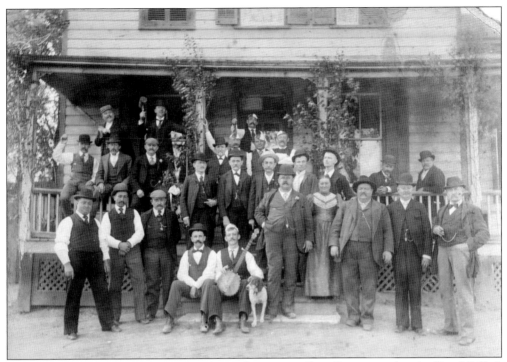

Except for "a few articles of furniture and a small quantity of beer," as reported in the *Signal*, Feller's original home and brewery was destroyed by fire on June 2, 1883. The foundation for his new residence and brewery started within a few weeks. An 1887 advertisement peddled, "John Feller, Breslau, L.I.—Brewer and Bottler of A 1 Lager Beer—Hotels and families supplied with fresh-bottled lager on Mondays, Wednesdays and Fridays." Ice supply was another of Feller's industries. In 1882, the "enterprising brewer" leased from John S. Krueger "the sole right to produce the frozen commodity." In 1896, he enlarged the pond and the icehouse to hold over 3,000 tons. The *Signal* declared that Feller "harvested six wagon loads of 3½ inch ice of a very fair quality. He intends to fill the house during the winter and will be fully prepared for next summer's rush."

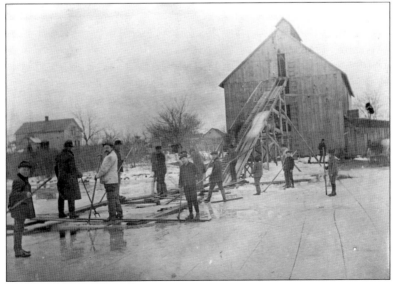

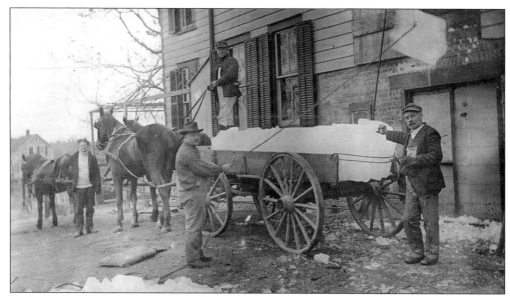

In the winter, the local newspaper often mentioned ice harvesters, who collected blocks up to nine inches thick and filled their houses "so that during next summer there will be no lack of ice, and cool drinks can be had without difficulty." In 1906, citing a local "ice famine," Feller erected a $5,000 artificial ice plant with a daily capacity of 10 tons, and used it to cool the adjoining brewery.

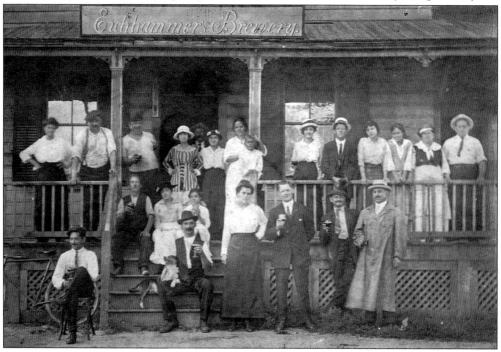

Around 1908, Joseph Hastreiter acquired Feller's brewery, which was later purchased by Otto F. Eichhammer, pictured in 1915. Eichhammer learned the brewing trade in Germany and often bought distressed taverns, fixed them up, and sold them for profit. His granddaughter, Johanna Sandy, recalls that Otto and his daughter, Johanna, came to Lindenhurst from Brooklyn by horse and wagon after reading in a German newspaper that the brewery was for sale.

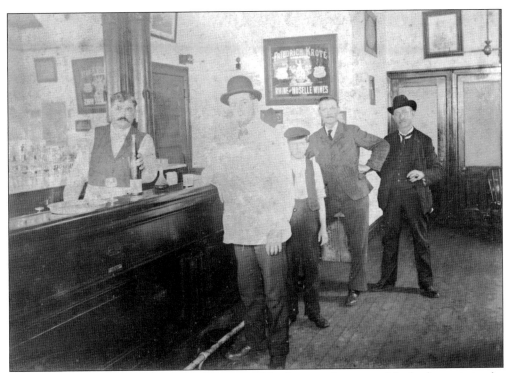

Eichhammer's front house welcomed guests and had rooms for rent, with the brewery in the back. Otto F. Eichhammer is behind the bar above. Otto's daughter, Johanna, learned the family business and married brewery employee Frank X. Graser. After Prohibition forced the brewery to close, Otto Eichhammer purchased Otto Krueger's Wellwood Avenue farm, near the present library. Krueger had been a manufacturer of artificial flowers often used in making ladies' hats. The Eichhammer homestead (below) had a large farmhouse, windmill, and icehouse, and Otto raised chickens, geese, ducks, cows, and horses and had an apple orchard for making cider. The old brewery site used by Feller and Eichhammer is now St. John's Lutheran Church. Once Prohibition was repealed, the brewery business was revived as Linden Brewery on Montauk Highway, not by Otto but by his daughter and son-in-law. (Below, courtesy of the Sandy family.)

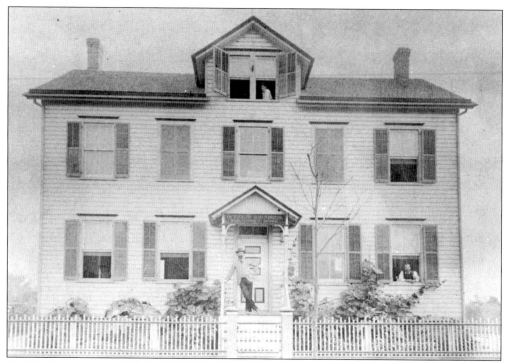

Suffolk County reportedly had 60 cigar manufactories producing 6.48 million cigars in 1885. Twenty of those businesses were in Breslau, six of which made over 120,000 cigars. In 1886, the top Breslau manufacturer was David Bendheim, with 729,950 cigars. Bendheim's cigar factory is pictured below around 1900 with his employees. The building was later used by the Catholic church as a school. Several ladies mastered the trade as well. Christina Gries learned to make cigars at the age of 12 in New York City, where she worked until she married Max Gnilka and they moved to Breslau. Christina worked for a few local manufacturers before establishing her own business from her home. She had tobacco shipped from Connecticut and manufactured her brands Wy-not and El Triumpho. Local hand-rolled cigar businesses faded away with the advent of automated facilities by the 1920s.

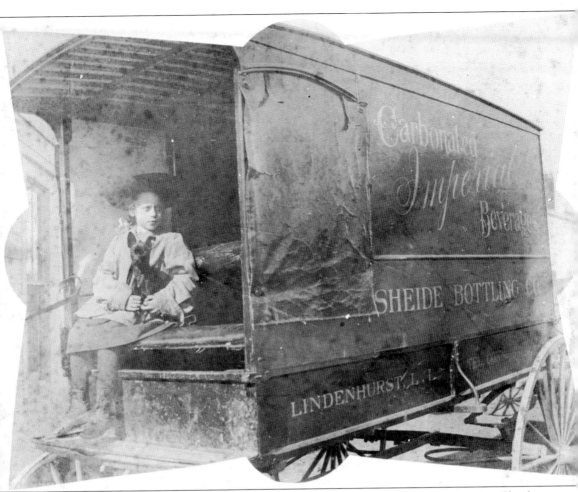

Marie Sheide Crosgrove, daughter of Fred Sheide and Agnes Wessell Sheide, poses in a Sheide Bottling Co. delivery wagon. In 1966, Marie shared the story of her parents' business with village historian Clara Kohmann. The business was started in 1900 after Agnes "learned the art of mixing the extracts for the soda in New York and used her talent in the business started by them in Lindenhurst. They started operations in the Dittmann building on New York Avenue and Pete Croce and his brother [Charlie] were their early employees. My father helped with the deliveries which were made by horse and wagon. When their business expanded and larger quarters were needed, they purchased the house on School Street," a former depot, school, and firehouse that still stands today. Sheide's was well known for its ginger ale and later bottled Ward's Orange-Crush.

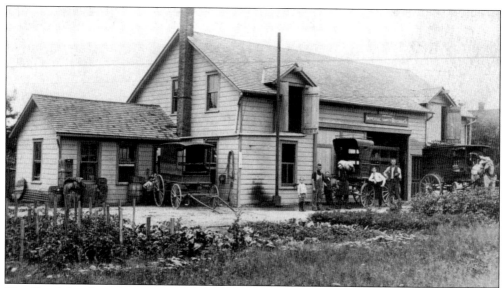

The Sheide bottling plant was on School Street. Keeping up with technology, delivery wagons were replaced by a motorized truck in 1913, and, according to the *Signal*, "an up-to-date bottle-washing machine . . . [the] only one of its kind on the island outside of Brooklyn" was added in 1914, when the company advertised, "Sheide Imperial Carbonated Beverages—Made of Pure Sugar and Under Sanitary Conditions. We invite inspection." The plant operated until 1933, after an increase in competition and Agnes's passing.

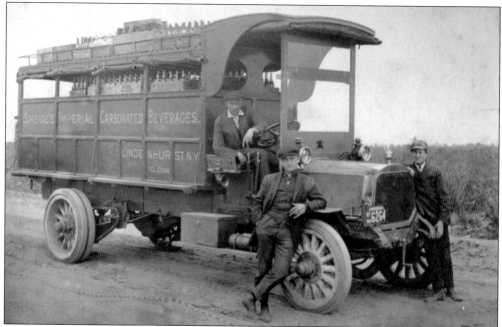

Pictured is a Sheide's Imperial Carbonated Beverages truck. An active community member, Fred Sheide was elected Babylon town clerk (1907–1911), to the state assembly (1911), and Babylon supervisor (1913–1917). In 1927, Sheide opened the Plaza restaurant and lounge on Montauk Highway, following the path of his in-laws, who owned hotels in Lindenhurst and at Linden Beach. In 1931, Prohibition agents raided the Plaza Hotel on a charge of beer running.

Five

LESSONS LEARNED
COUNTRY SCHOOLS AND
EDUCATIONAL INSTITUTIONS

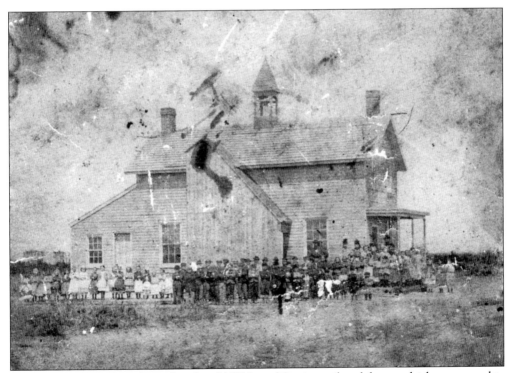

Breslau's first school was formed in the old Welwood Station railroad depot, which was moved to School Street in 1870 and is pictured around 1874. Emphasizing the heritage of the early Breslau settlers, lessons were originally given in German. In 1873, the *Brooklyn Daily Eagle* reported that there were 240 registered students, although the average attendance was only 200, and the school was "prosperously conducted by a German gentleman."

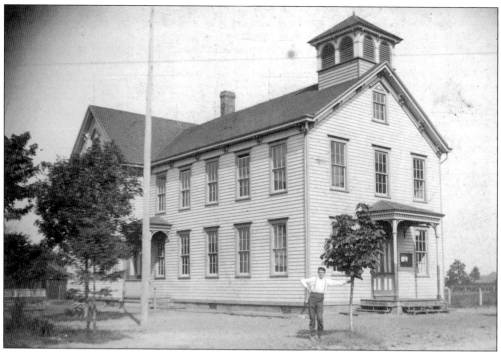

After a few years, the student population increased and outgrew the old depot schoolhouse. In 1876, the community erected a new four-room schoolhouse on School Street just south of the original school. The building was enlarged with a 22-by-35-foot extension in 1899 and was used until 1910, when it was replaced by a new three-story brick school, again situated on the aptly named School Street.

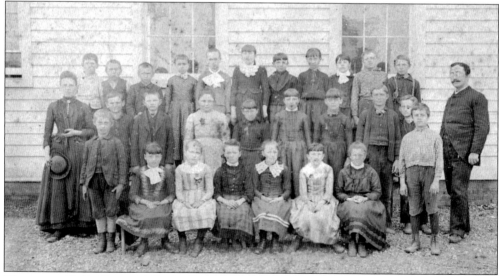

Class was guided by Principal George Zoellner (far right) in 1890. Zoellner apparently had numerous critics. In 1894, the *Brooklyn Daily Eagle* reported that Zoellner had been labeled "an anarchist" by local church leaders. Zoellner denied the charge, and the *Eagle* claimed, "the charge originates in his refusal to submit to the intermeddling of the clergymen in the affairs of the school. The school trustees are said to sustain the principal."

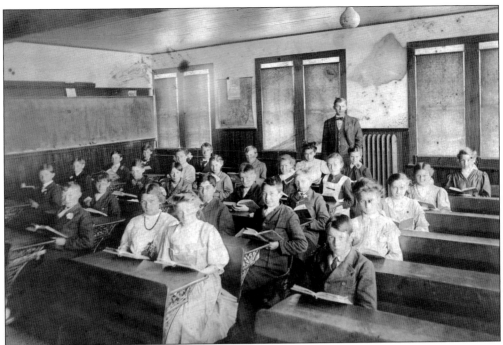

Pictured is the 1907 classroom of Reinhold Mertching, who taught English language lessons in the grammar department. He also served as the school's principal with the yearly salary of $750. In 1902, the *Signal* reported that Mertching had "taken unto himself a life partner" and informed the community that "the opening of school has been deferred until Monday, September 8, in order to allow the principal and his bride to enjoy their honeymoon."

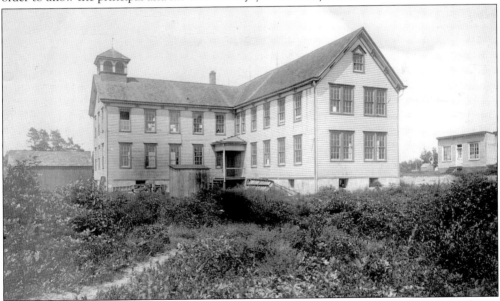

This quaint school educated local students from 1876 to 1910. The old school was moved west to North Fourth Street and repurposed as a factory, first for manufacturing shoes and later for embroidery. The old timber building succumbed to fire on January 6, 1960. Its last occupant was the Staple Coat Retail Outlet.

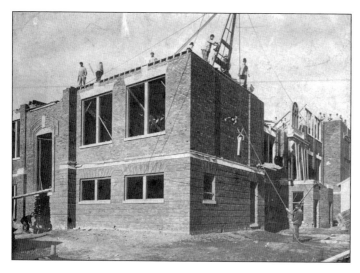

By 1907, the board of education purchased 14 lots on School Street for $5,500 and started making plans for a $45,000 modern school with 16 classrooms. The price had tripled in the 14 years since the board first considered the land purchase. Architects Lewis Inglee and Charles Hart of Amityville were engaged to draw the plans. George E. Libbey of Brooklyn was hired for the construction, as pictured in 1910.

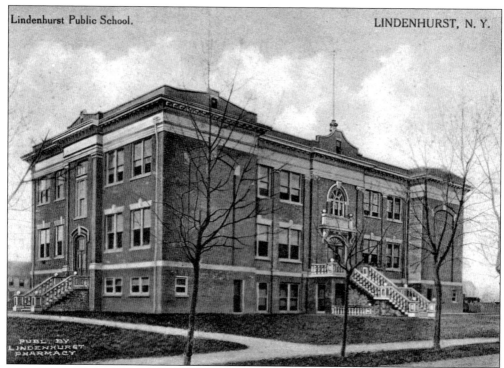

School Street School was ready for students in the fall of 1910. The three-story brick structure, trimmed with Roman stone, had a 600-person auditorium, seven entrances, and up-to-date amenities including a fire alarm, electric lights, and a drinking fountain. The *Signal* declared Lindenhurst "rewarded by having one of the finest school buildings on Long Island." The majestic building guided the education of several generations but fell victim to demolition in 1987.

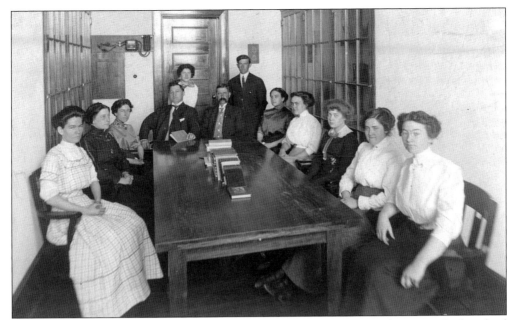

The faculty of the new School Street School in 1911 was, from left to right, Agnes Bosley, third grade; Marie Lynch, fourth grade; Ann McHenry, second grade; principal O. Nelson Duesler; George Jommes, board of education; Joseph Baumer, eighth grade; Harriet E. Kelly, seventh grade; Augusta Martini, first grade and German; Caroline Burne, sixth grade; Helen Rogers, kindergarten; and Elizabeth McHenry, fifth grade.

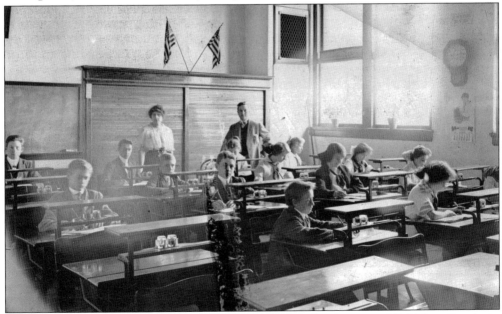

The classroom of commercial teacher Lelia Baker is pictured with principal O. Nelson Duesler in 1914. This teacher instructed students in a variety of business and work-related areas, including penmanship, bookkeeping, stenography, and farm management, as dictated by the employment needs of the community. Students wishing to continue their studies past the eighth grade could transfer to a nearby high school. Lindenhurst did not build its own high school until 1931.

Honoring the famous canal, the Panama Athletic Association formed to establish school sports teams and a gymnasium "in order to play games and take some muscular exercise during the cold blasts of winter" in 1913. The *Signal* proclaimed, "Uncle Sam believes that 'all work and no play makes Jack a dull boy,' and the boys and girls of Lindenhurst are with Uncle Sam in the construction of the Panama canal."

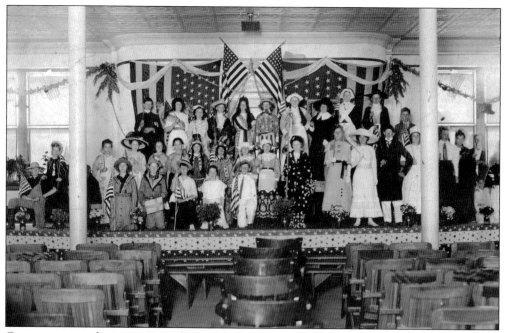

Community members were invited to attend a 1913 school production. The *Signal* reported that "The pupils of Lindenhurst school are preparing a Christmas entertainment to be given in the auditorium of the school. . . . The programme will consist of instrumental and vocal music, recitations and character sketches. Santa Claus will appear in person to distribute his favors. Two hundred children will sing the opening and closing choruses and Wrieth's orchestra will be on hand."

Six

GROUP DYNAMICS
CLUBS AND ACTIVITIES

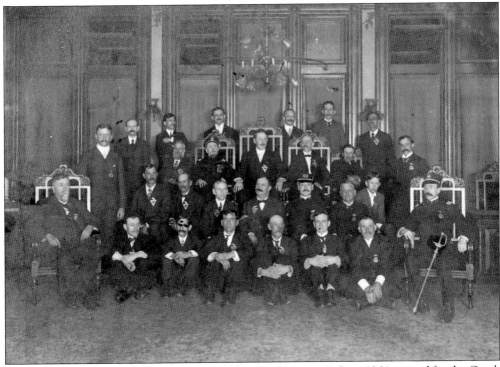

The fraternal Knights of Pythias were formed in Washington, DC, in 1864, named for the Greek legend of the friendship of Damon and Pythias. Local units or "castles" included Anchor Lodge, Babylon, established in 1881, and Unqua Lodge, Amityville, established in 1883. The Wilhelm Tell Lodge (shown) was initiated in Breslau on December 30, 1882. At induction, members received swords inscribed "FCB" for the Pythian motto "Friendship, Charity, Benevolence."

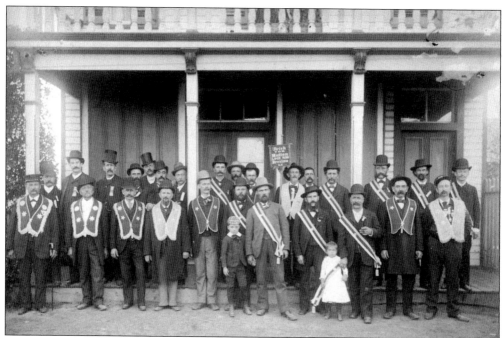

The Ulrich Von Hutten Lodge of the Sons of Liberty of the State of New York was chartered in Breslau in 1888. Named in homage to the German Reformationist scholar, poet, and satirist, the order proposed building a home for the poor, infirm, widowed, and orphaned brethren, modeled after the Long Island Home in Amityville. Despite years of fundraising, plans never came to fruition, and the lodge was dissolved in 1896.

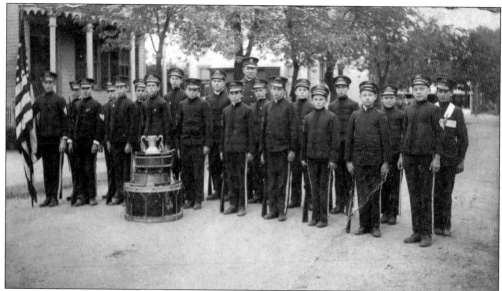

The local Boys' Brigade, similar to Boy Scouts, is pictured around 1910. The *Signal* reported, "Acting Captain W.F. Wild [rear, center] . . . was presented with a beautiful pearl handled knife as a token of their esteem. The boys in return were given their first allotment of rifles for drill work. . . . The boys were on the streets a few evenings ago marching and drilling and drew applause from all for their clever work."

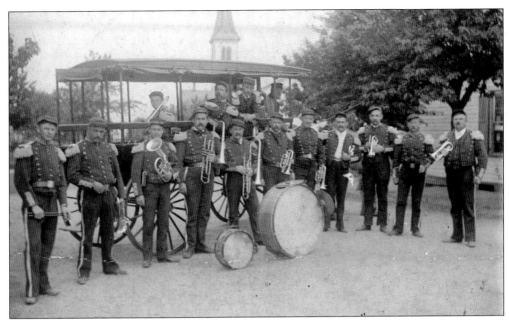

The Breslau Cornet Band is pictured with its stage wagon in 1895. In 1889, the *Signal* announced that visiting trombonist Ewald Stolz composed a march for the band and "on account of the lessons which they enjoyed under the instruction of the eminent musician, have improved wonderfully." In August 1888, the *International Trumpet Guild* journal described Stolz as "one of the greatest trombone players of the world to-day."

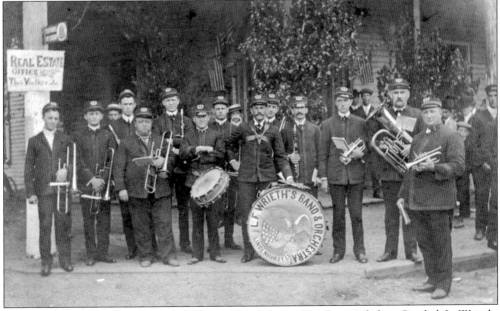

Louis F. Wrieth's band is pictured at Gleste's Hotel about 1904. Louis's father, Gottlieb L. Wrieth, owned a hotel at the northeast corner of Wellwood and Hoffman Avenues. The March 9, 1901, *Signal* excitedly proclaimed "the first dance under the auspices of L.F. Wrieth's Brass Band and Orchestra is announced for Saturday, April 27, at Washington Hall. Bear the date in mind, and make no other plans for that evening. Tickets, admitting one, ten cents."

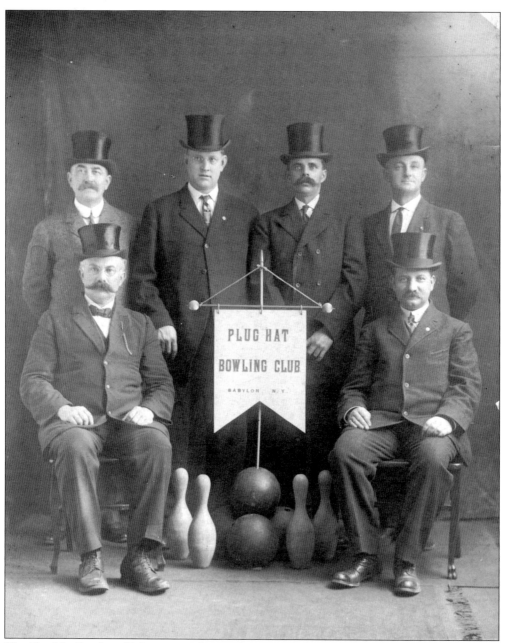

The Plug Hat Bowling Club is pictured around 1913. From left to right are (seated) Peter Nuener, team captain, and Charles Vollmer; (standing) Charles Baiter, George Otten, Otto Vetterly, and Charles Bruno Gnilka. Taking their name from a popular style of top hat, the club was active from around 1910 to 1914 and played at area bowling alleys, including those in Sayville, the Alhambra Opera House, the amusement hall in Babylon village, and the lanes at Gleste's Hotel. In a display of team rivalries, the December 16, 1910, *South Side Signal* reported, "A picked team of the Thursday Night Bowling Club . . . went to Babylon last Friday evening and were trimmed for three straights by the Plug Hat Club at the Alhambra. A return game will be played at Gleste's alley tonight . . . and it is said the Plug Hats will be served up some of their own bacon."

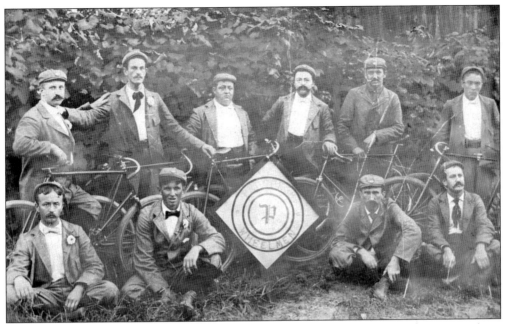

The decade's bicycling craze inspired the 1896 formation of the Progress Wheelmen, whose excursions went as far as Bohemia, Hicksville, and Jamaica. Local bicycle dealer and repairman William F. Wild advertised "a full line of [bicycle] sundries and parts always on hand." The *Signal* published a challenge from the Lindenhurst Wheelmen to race a member of the Progress Wheelmen "for a prize to be decided upon."

Brothers-in-law August Voldenauer (left) and George Weierter, both members of the Union Hook and Ladder Company, pose with their bicycles around 1900. Weierter, a Progress Wheelmen member, was a contractor who built many Lindenhurst buildings, including the National Theatre. Voldenauer, a merchant, held many public offices including school truant officer, president of the Lindenhurst Board of Trade, and keeper of the Riverhead Jail under Sheriff Henry Brown.

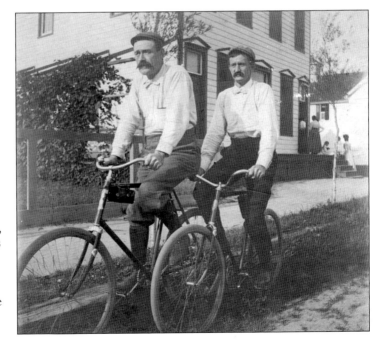

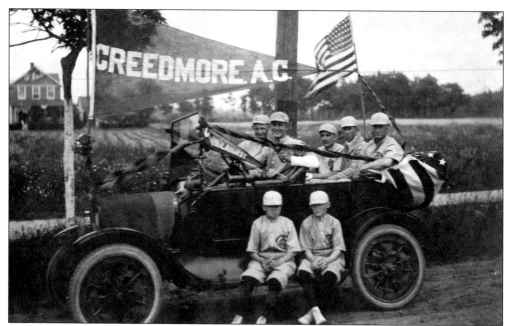

Members of the Creedmore Athletic Club pose with a car decorated for the 1920 parade celebrating the community's 50th anniversary. The Creedmore Athletic Club formed in 1914 to promote athletics and established a clubhouse behind the National Theatre where it "installed various indoor athletic paraphernalia," according to the March 17, 1916, *Signal*. The South Shore Baseball League, formed in 1919, included the Creedmores and teams from Babylon, Bay Shore, Sayville, and Patchogue.

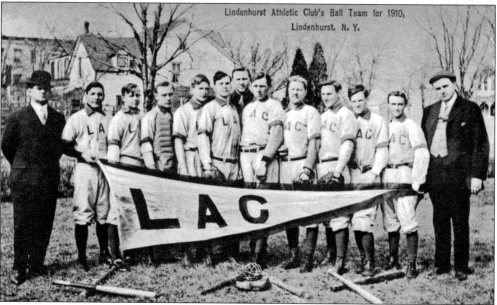

The Lindenhurst Athletic Club baseball team is pictured in 1910. Club members held fundraisers for uniforms and equipment. The *Signal* congratulated the club on its 1895 masquerade ball at Gleste's Hall: "It was undoubtedly the most successful ball. . . . Fully 300 persons were present, and over one hundred were masked. . . . The hall was beautifully decorated, and was lighted with a calcium light [limelight]. The effect was beautiful." The club was formed in 1893 and disbanded in 1921.

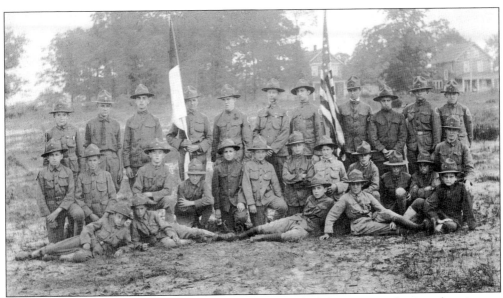

Boy Scout Troop 60 (above) formed in 1918. Scouts furnished their own uniforms and equipment and paid a 25¢ membership fee and 10¢ monthly dues. To celebrate the February 1919 Scouting movement anniversary, the *Signal* reported that Boy Scouts took a hike to Pinelawn (East Farmingdale) "where they cooked dinners in regular scout fashion," attended a St. John's church service, and held a celebratory dinner at Feller's Hall with 18 Girl Scouts as their guests. Also formed in 1918, the Lindenhurst Girl Scout troop poses below at the School Street School after marching in the 1919 Decoration Day (Memorial Day) parade. In April 1919, Scoutmaster Robert W. Wild led 40 Boy Scouts and Capt. Louise Weierter led 20 Girl Scouts by special trolley to Babylon and acted as honor guard for James W. Gerard, former US ambassador to Germany, who spoke at the Church Institute.

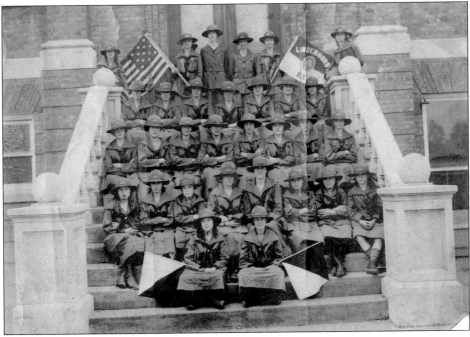

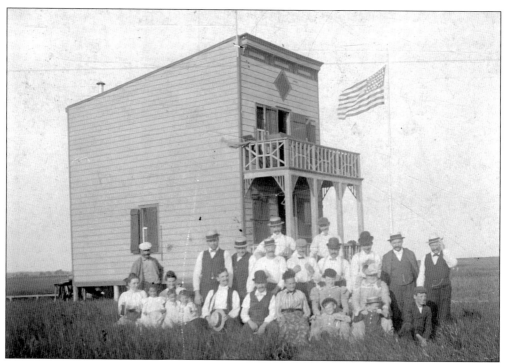

As their name implies, members of the Phoenix Rod and Gun Club enjoyed fishing and hunting, as pictured at their clubhouse, formerly situated on the marshlands along the Great South Bay. In the early years of the group, the July 24, 1897, *Signal* reported, "Quite a number of members of the Phoenix Rod and Gun Club are at the clubhouse at the foot of Wellwood avenue, and are having no end of fun fishing, sailing, bathing, etc. The club men are all jolly fellows, and if there is any fun to be had, afloat or ashore, they are sure to find it." Primarily comprised of Brooklyn and Manhattan residents, the club was dissolved in 1917.

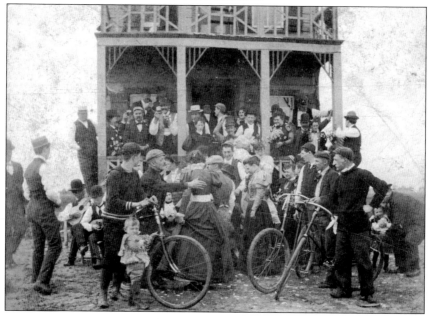

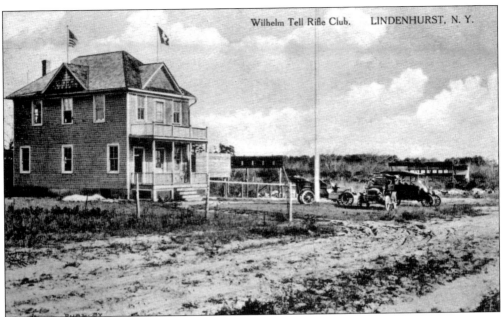

The members of the Wilhelm Tell Rifle Club, formed in 1909, engaged in shooting competitions against one another and other clubs. Named for the Swiss folk hero and marksman, the clubhouse was adorned with a Swiss flag and an American flag for its formal dedication on May 28, 1911. Later that summer, the club hosted the United Swiss Shooting Clubs of America for its annual Bundesfest shooting festival. The 200-foot target range at the Herbert Street complex could accommodate 10 riflemen simultaneously. Targets were placed in a concrete house connected to the clubhouse by telephone. The September 1, 1911, *Signal* described the event: "By a clever electrical scoring apparatus the various scores were immediately flashed before the official scorer, allowing no delay in the contests." The old clubhouse was later expanded to form the current American Legion hall.

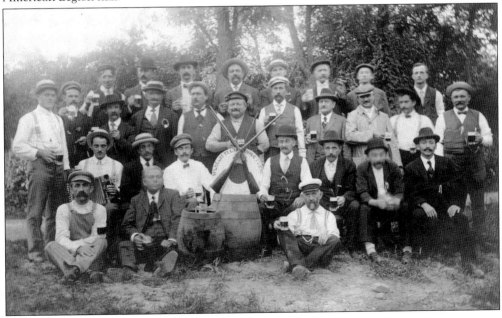

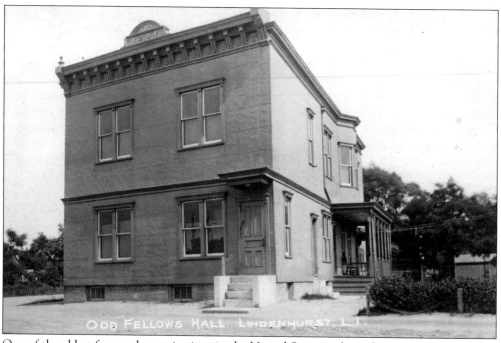

One of the oldest fraternal organizations in the United States is the Independent Order of Odd Fellows. Breslau Lodge No. 524 organized in 1885. Active in the community, the lodge fundraised for the erection of a clubhouse at the southwest corner of Hoffman Avenue and Travis Street. The lodge held its first meeting in the hall on February 16, 1910. The initials I.O.O.F. can still be seen at the top of the building.

Pictured is the Rebekah Lodge class of 1924. Local women formed G.D. Meinen Lodge No. 119, Daughters of Rebekah, an independent branch of Odd Fellows, originally exclusive to women. Celebrating their fourth anniversary, an 1894 *Signal* announced, "The annual concert and picnic of G.D. Meinen Rebekah Degree Lodge takes place at the Washington Pavilion . . . no one who is in search of an evening's pleasure should miss it. See hand bills for particulars."

A parade and firemen's tournament was held on June 28, 1920, to celebrate the 50th anniversary of the community's founding. Despite the rainy weather, the July 2, 1920, *Signal* declared that "Lindenhurst lived up to her reputation as a doer of big things," in that the nearly 8,000 people assembled were "either fed, entertained, protected and cared for without an accident, arrest or any unpleasant incident to mar their pleasure." The parade began at 11:30 a.m., headed by grand marshal Charles Helling and police chief Herbert Mielke. The hour-long parade included "800 uniformed men, 50 fire apparatus, including racing outfits, 20 bands and drum corps. There was only one horse drawn truck, the balance being motorized, showing a positive indication of a new era of a motor age." Many local organizations decorated motorcars and marched in the parade to demonstrate their community pride, as showcased in the following images. Foresters of America Court Lindenhurst No. 498 decorated its truck in stars and stripes. The local Foresters Court organized in 1910, held local benefits, and was active in the community.

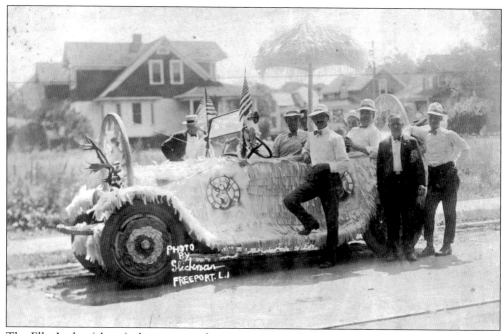

The Elks Lodge (above) also got into the semicentennial spirit with a car festooned with crepe paper and a jaunty umbrella. Positioned near the Sheide beverage truck (below), local women of the American Red Cross pose with a young Uncle Sam and Lady Liberty. A Red Cross chapter formed in Lindenhurst in 1917 under chairwoman Georgia Ackerly. The October 12, 1917, *Signal* informed the public that Rosa Ramsauer offered use of her family's plumbing and tinsmith shop on Wellwood Avenue to "the new auxiliary which was accepted with thanks. Mrs. [Lillian] Boehl, who is an expert with the knitting needle, also offered to give one evening each week at the headquarters to instruct any who desire to knit sweaters, etc. for our soldier boys."

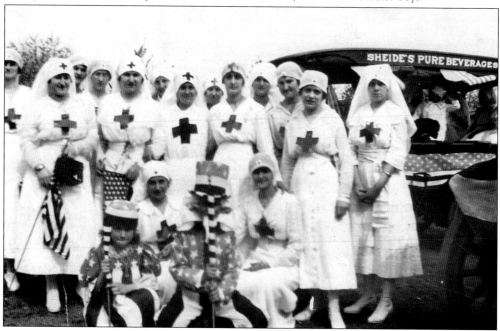

Seven

DUTY BOUND

FIRE DEPARTMENT, VETERANS, AND SERVICE ORGANIZATIONS

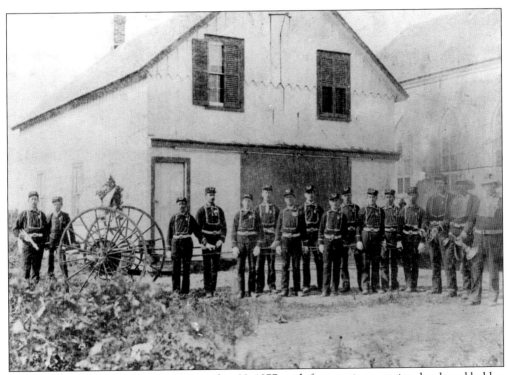

Breslau Feuer Wehr organized on November 29, 1877, with four sections: engine, hook and ladder, hose, and watchman. In 1882, Feuer Wehr reorganized as Breslau Engine Company No. 1, and in 1885, it joined Liberty Hose Company No. 1 and Union Hook and Ladder Company No. 1 to form the Breslau Fire Department. The name "Lindenhurst Fire Department" was not adopted until 1909. Pictured is the Liberty Hose Company's West John Street headquarters in the 1890s.

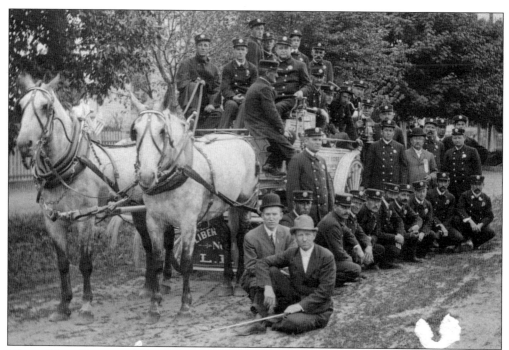

Liberty Hose Company No. 1 is pictured with its newly acquired hose cart in 1910. That year, Decoration Day exercises were announced in the *Signal*, including "A test of the new hose apparatus . . . in front of Liberty Hose Company and every effort will be made to make the test thorough. A large quantity of new hose has arrived and the work of enlarging Liberty Hose headquarters [Wellwood Avenue] is progressing quickly."

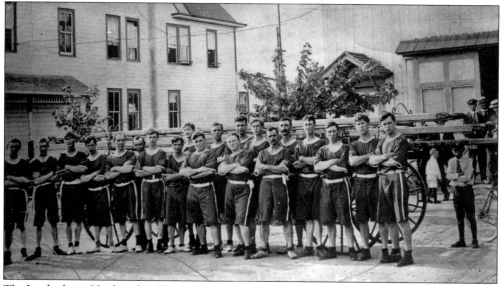

The Lindenhurst Hook and Ladder Running Team in 1906 competed at the annual Suffolk County Volunteer Firemen's Association tournament in Greenport. That year, the department jubilantly returned home "with four prizes—second prize, Hook and Ladder No. 1, third prize, Hose No. 2, first prize hand engine, and second prize in ladder scaling contest, Frank Seegott the nimble climber taking second place after tying for first," according to the September 15 *Signal*.

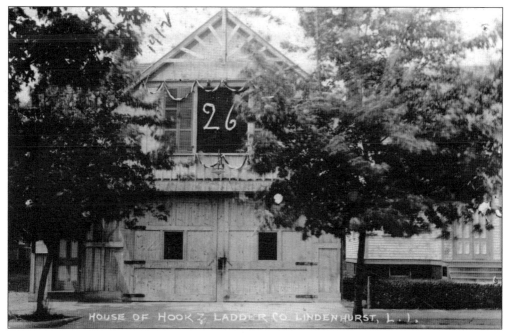

HOUSE OF HOOK & LADDER CO. LINDENHURST, L. I.

The arrival of a new horse-truck at the Union Hook and Ladder firehouse was met with celebration, and the firehouse was decorated with flags and flowers. The August 19, 1882, *Signal* reported, "The Breslau Brass Band 'hove in sight', and Union Truck Company, headed by the band, paraded through the village. Torches blazed and large numbers followed . . . to Gleste's Hall, where the music struck up and the firemen and their guests participated in the giddy waltz."

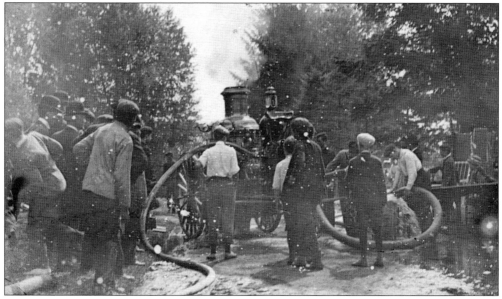

In 1891, the Breslau Engine Company supplemented its hand-powered apparatus by purchasing its first steam engine, "Lady Warren," for $800. The "old reliable steamer" was retired and sold in 1912. The *Signal* proclaimed, " 'Lady Warren' has been an important factor in the saving of many buildings in Lindenhurst during the last decade, and came into much prominence three years ago when one of the asylums at Amityville was threatened by fire."

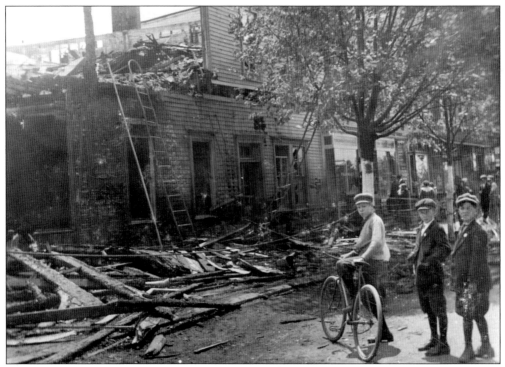

On June 2, 1912, Gleste's Hotel at Hoffman and Wellwood Avenues succumbed to a blaze that brought brigades from Babylon, Amityville, Farmingdale, and the Vulcanite factory to help local firemen, who fought flames from 2:00 p.m. to nearly midnight. The *Signal* reported that visiting Patchogue ball players and other hotel guests lost their belongings, "much wine was stolen out the cellar," and a cash register full of money "melted under the blaze."

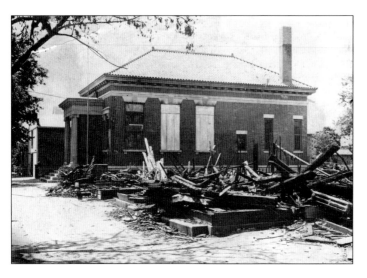

Edward and Flora Gleste's Wellwood Avenue home was destroyed by fire on June 20, 1914, along with that of neighbors Frederick and Anna Kienle, five barns, and a windmill. George Gleste lost his second fireman's uniform in the house fire, having lost his first uniform two years prior in the hotel. The brick bank building reportedly acted as a fire wall, keeping the fire from spreading.

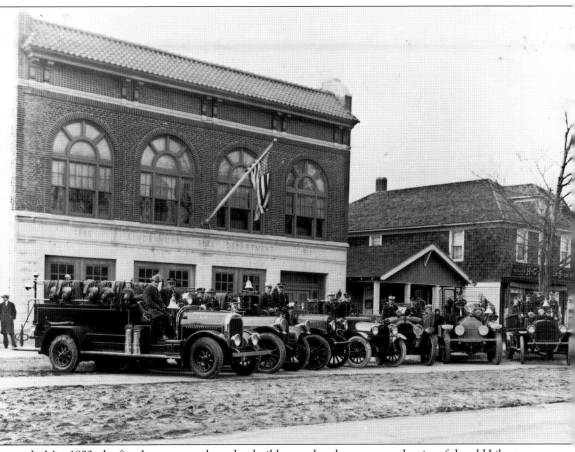

In May 1922, the fire department elected to build a new headquarters on the site of the old Liberty Hose Company firehouse on South Wellwood Avenue. The following year, the department sold the West John Street property to St. John's Lutheran Church, sold the old Liberty Hose firehouse, which was moved by Dittmann Bros. to South First Street, and broke ground for its new headquarters. The May 25, 1924, *New York Times* reported that "The new $100,000 Lindenhurst Fire Department building on Wellwood Avenue was formally dedicated and opened for inspection today, following a parade of the firemen through the street with the six pieces of apparatus. Addresses were made in front of the new building by Fire Chief Joseph J. Schmitt and Village President Gustav Hahn. The building is a two-story brick and marble structure and is equipped with all modern facilities. On the upper floor are pool tables and a recreation room for the firemen." The historic firehouse, pictured in 1927, was razed in 2013 for construction of enlarged headquarters. (Courtesy of the Town of Babylon History Museum.)

Prussian-born Charles F. Pluemacher immigrated to the United States in 1857 at 20 and fought for the Union in the 1862 Battle of Antietam. He purchased a pocket watch after the war but sent it to the Virginia governor after discovering it was stolen from a dead Confederate soldier. The watch is now with the American Civil War Museum in Richmond, Virginia. Pluemacher (standing fourth from left) joined Adam Wirth Post No. 451 of the Grand Army of the Republic, pictured in 1910. He later moved to North Fourth Street and was the last local Civil War soldier to pass away. Pluemacher had a factory producing tuning forks and acoustic instruments at College Point. Known for his remarkably trained ear, Pluemacher was sought by Kaiser Wilhelm II to train German soldiers in projectile velocity identification prior to World War I; he refused the kaiser's offer.

On New Year's Day, 1918, a dedication ceremony was held for the national flag and a service flag honoring the 49 local servicemen. Before a group of over 500 people, 91-year-old Civil War veteran Conrad Pfurr raised the flags on a new 85-foot flagpole known as the Liberty Pole at the railroad station. A committee chaired by George Pebler, formed just two months prior, raised funds by hosting a vaudeville show at Washington Hall.

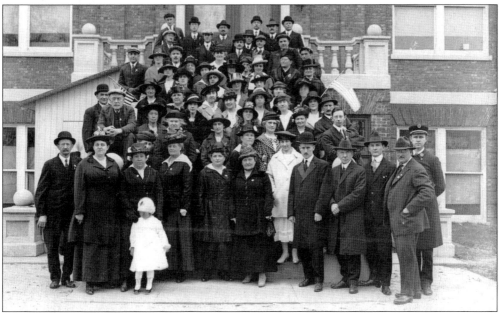

The Liberty Loan Committee of Lindenhurst, pictured in 1918, sold Liberty war bonds for the Allied cause during World War I. The local committee, chaired by Albert A. Arnold, more than doubled its $29,000 quota, raising $63,100. The campaign concluded with an automobile parade through the village that culminated with the raising of an honor flag at the Liberty Pole. Factories were asked to close in time for the parade.

To raise further funds, the Victory Loan Committee held a whippet tank exhibition on May 5, 1919. The *Signal* announced, "factories and school will close and everybody will join in the demonstration. [Louis] W. Irmisch has given permission to allow the tank to dive in the old Gleste cellar. . . . Scoutmaster Robert Wild will have his boys on the job to perform anything necessary to promote enthusiasm. J.P. Warta will have charge of the musical features and . . . there will be a big rally at the school assembly hall." The *Signal* later reported that "the tank was escorted thru the streets by the Victory Loan committee, boy scouts and other citizens. The tank went in and out of the Gleste cellar at the corner and also showed off in the woods near the Bartholet home. Following a war veteran's speech, $35,000 was subscribed."

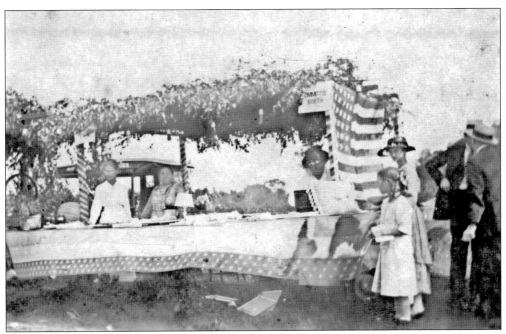

In January 1919, the Honor Roll Committee formed to erect a memorial recognizing Lindenhurst servicemen of the Great War. By that summer, the committee had raised $1,500 toward the $2,500 project through community donations, moving picture shows, and dances. To complete its goal, a two-day carnival benefit was organized with booths supported by local groups (above), including Scouts and Court Lindenhurst, Foresters of America. Reporting that the Vulcanite Manufacturing and Lindenhurst Manufacturing Companies had each donated $100 to the fund, the *Signal* declared, "All arrangements have been completed for the carnival, which will open with a monster parade starting from the fire headquarters. . . . There will be all kinds of attractions and amusements with dancing in the afternoon and evening." Construction of the monument plaza is pictured below on October 29, 1919.

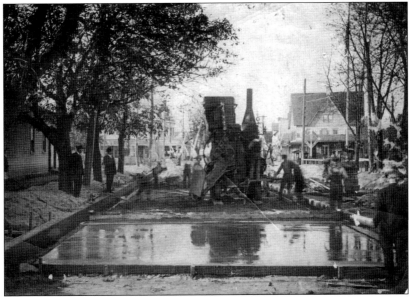

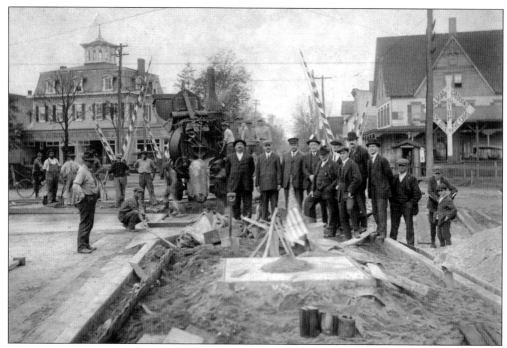

The monument site, in the middle of Wellwood Avenue south of Hoffman Avenue, was a dirt street. The Babylon Town Board directed highway superintendent William Wilmarth to lay a 150-foot concrete road on either side of the site. The Honor Roll Committee took charge of placing curbs, and local merchants were encouraged to curb the front of their properties. This appears to be the first concrete road through the downtown.

Dedication day was Thanksgiving 1919. Grand marshal Charles Heling led the parade from the East John Street fire headquarters. The memorial of Stony Creek granite stood seven feet high, surmounted by a bronze eagle with its wings spread four feet. The bronze plaque was inscribed with the names of 101 servicemen and four merchant marines. A wreath was laid by Sgt. Warner Frevert to honor the three local soldiers killed in service.

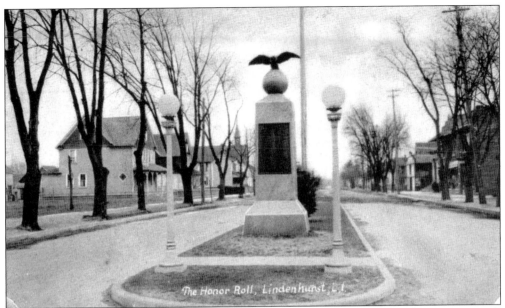

The board of trade issued a compliment and invitation to the monument committee. The March 5, 1920, *Signal* noted, "With the addition of this committee, a great majority of whom are women, to the membership of the Trade Board the Village can depend upon seeing many improvements in the near future for never in the history of the community did a committee meet more obstacles and accomplish bigger results than did the Honor Roll committee."

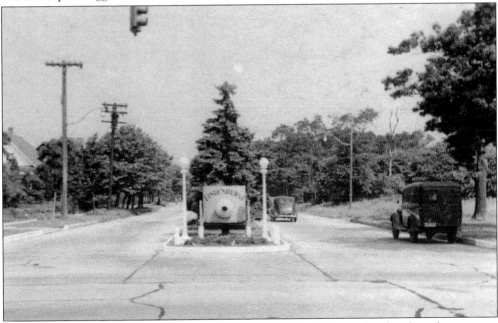

In December 1921, the Lindenhurst Board of Trade, the precursor to the chamber of commerce, gratefully accepted a 1,200-pound Gatling gun and carriage used during World War I, offered to the community by the War Department. The name "Lindenhurst" was painted on the gun shield, and the retired weapon was placed in time for Memorial Day on a custom concrete base on the north side of Montauk Highway and Wellwood Avenue, where it remains.

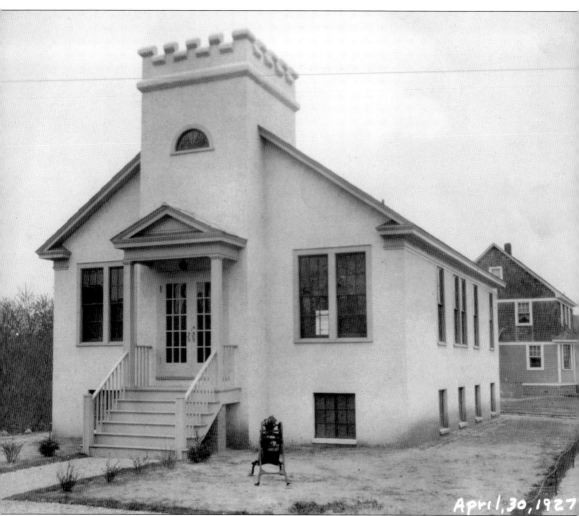

April, 30, 1927

Soon after the Honor Roll dedication, 38 local veterans organized the World War Veterans Club, electing John Blankenhorn the first commander. They began fundraising for the erection of their clubhouse, which was dedicated on April 30, 1927, on the southwest corner of West John Street and Broadway. The fortress-like building was designed by Harry G. Wichman and constructed by George F. Weierter and was finished in Magnesite stucco with a prominent watchtower and parapet. The World War Veterans Club and Ladies Auxiliary were active in the community until the late 1990s and included World War II and Korean War veterans. American Legion Post 1120 was formed in 1934, named Feustal-Kurdt Post in memory of Lindenhurst residents William Feustel and Martin Kurdt, killed in action during World War I. Wade-Burns Post 7279, Veterans of Foreign Wars, was chartered in 1946.

Eight

SPIRITUAL GUIDANCE
HOUSES OF WORSHIP

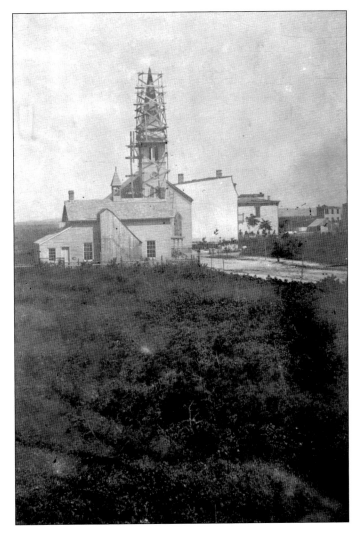

Evangelical St. Johannes Church of Breslau, pictured under construction, was designed and built by Charles Wuensch. The church was formally dedicated on August 26, 1872, by the congregation's first minister, Rev. A. Stoll. Suffering from financial difficulties, the church disbanded in 1875. Early the following year, a new congregation formed, Evangelische Lutherische St. Johannis Gemeinde, or St. John's Evangelical Lutheran Church, which later acquired the church property. The first Breslau school is in the foreground.

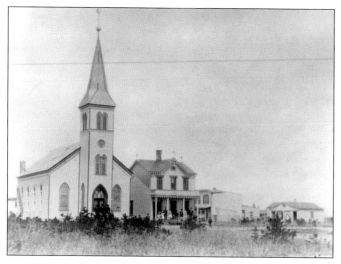

The first minister of St. John's Lutheran Church was Rev. George W. Drees, who worked diligently to acquire the church property on West John Street, which had been seized by the Suffolk County sheriff for unpaid debts. After purchasing the property, members thoroughly repaired and renovated the buildings and formally dedicated the church on October 11, 1885. The church and parsonage are pictured around 1895.

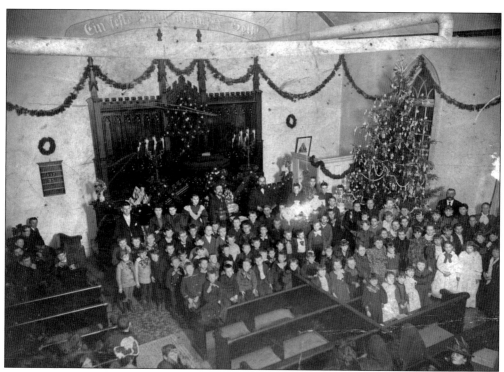

St. John's Lutheran Church's 1894 Christmas services were conducted by Rev. August W. Bertram. Like his predecessor, Reverend Drees, Bertram was a German native. Reverend Bertram died of typhoid fever in 1896 and was succeeded by Rev. Edward Stauderman, who introduced monthly services in English, although most services continued in German. Reverend Stauderman oversaw church renovations, including the first stained-glass windows and a new 700-pound bell for the steeple.

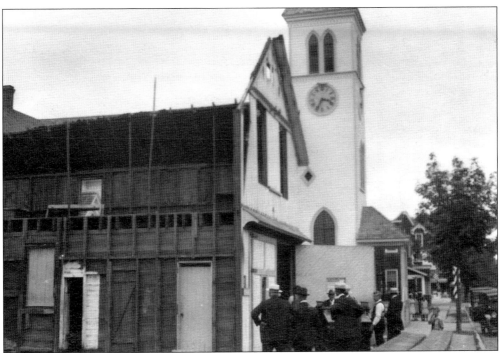

A new constitution, in English, was adopted in 1917, formalizing the church's anglicized name, increasing council membership to 12, and guaranteeing voting rights for women in church meetings. The women of St. John's were very active. The Ladies Aid Society, established in 1876, still exists, the oldest organization in the church. In 1925, St. John's purchased the old firehouse on the west side of the church for $3,000 for use as a parish hall.

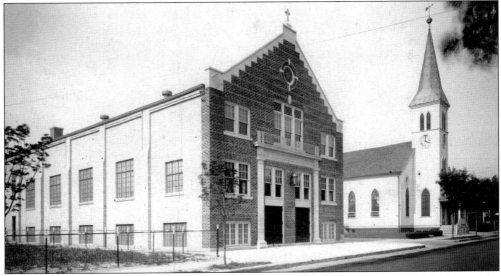

The year 1926 brought tragedy and triumph for St. John's. Fire destroyed the old firehouse, the cornerstone for a new hall was dedicated on August 1, and the completed Church House was dedicated by Rev. August Westlin on December 19. The growing congregation eventually needed a new church, but it did not move far. In 1960, a new church was dedicated on East John Street, where the congregation remains active.

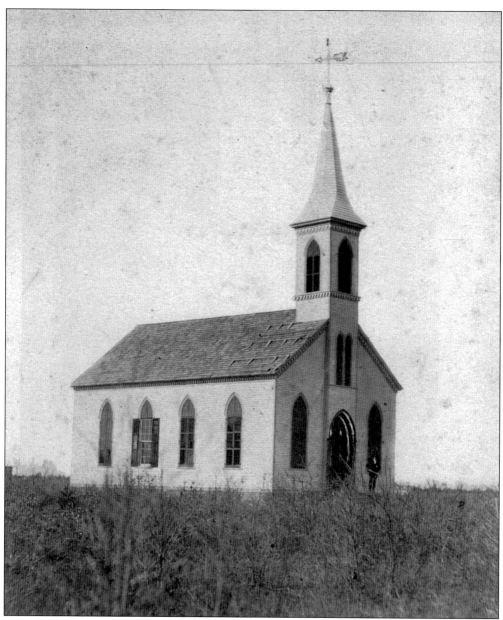

In an 1871 article celebrating the first anniversary of Breslau, the *Brooklyn Daily Eagle* reported that the Breslau Building Association, managed by Thomas Welwood and Charles Schleier, "offers to donate an ample site for churches and school houses to any and all religious societies making application, and without distinction on account of creed or denomination." The *Eagle* further noted that the Catholic church and German Lutheran church had been established and plans were made for a Baptist church and Hebrew temple as well. The cornerstone for this 30-by-50-foot Baptist church was laid on March 17, 1872, and the church was dedicated on May 20. The *Signal* relayed that "the Society numbers 22 persons and has quite a large Sabbath School. The money [$3,000] to build the edifice was generously advanced by a Williamsburgh gentleman." This Baptist church was short-lived and appears to have closed by 1874. A few decades later, Baptist congregations returned to Lindenhurst.

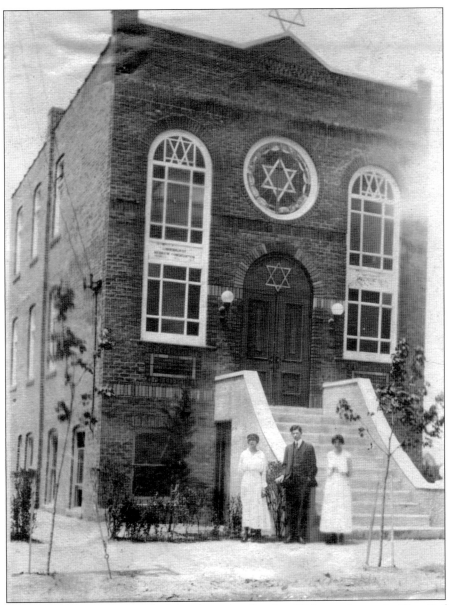

The Hebrew Congregation of Lindenhurst formed in October 1913, meeting at the West Hoffman Avenue embroidery building owned by brothers George and Louis Barasch. The congregation purchased lots on the northwest corner of West John and North Fourth Streets. While fundraising for synagogue construction, services were temporarily held at the home of Rabbi Benjamin Diamond on South Eighth Street. Over 300 people attended the June 20, 1915, cornerstone ceremony. Built by George Weierter, the brick-and-stone synagogue was formally dedicated on August 29, 1915. Members marched from Rabbi Diamond's home to the synagogue, led by Posniak's Orchestra of Brooklyn. Congregation president Abraham Weinstein led afternoon ceremonies and "a chicken supper was served in the dining rooms below the main floor in the evening with music enlivening the affair," according to the September 3, 1915, *Signal*. Other early Jewish organizations included the Breslau Hebrew Cemetery Association, incorporated in 1887, and the First Lindenhurst Hebrew Society, formed in 1908.

Lindenhurst's first Catholic church was dedicated on August 15, 1871, on Bismarck Avenue, now South Eighth Street. The *Signal* noted that the railroad "ran an extra train from Brooklyn to this place for the accommodation of those wishing to attend." A small cemetery remains on South Eighth Street near the site of the original church. The congregation started construction on its second church on South Wellwood Avenue, shown here, in 1905.

Our Lady of Perpetual Help R. C. Church, Lindenhurst, N. Y.

Our Lady of Perpetual Help was dedicated on Thanksgiving 1905. The *Signal* described the event: "The sacred edifice erected at a cost of $15,000 by the contractor, Jabez E. Van Orden, is an imposing building, and ornament to the village, and reflects much credit upon the thrift of the community." Rev. Fr. Gustav Baer of Woodhaven delivered the sermon in German, while Bishop Charles E. McDonnell made his address in English.

The *Signal* continued, "The interior of the edifice is rich in churchly effects. Three altars occupy the customary position in the chancel. The pews and confessional are of quarter oak, while the windows are of opalescent glass. The general style of the interior is Romanesque and the effect is very pleasing." The wooden church was demolished in 1959 for construction of a new 1,000-seat church and rectory on the site.

First Holy Communion is pictured at Our Lady of Perpetual Help in 1915. In 1907, the *Signal* described the first communion services for 17 children: "Each candidate was accompanied by a candle bearer, making thirty-four in all and the sight was a very pretty one. The church presented a very attractive appearance, being decorated by Michael Fortunato with palms, sweet peas, carnations and other flowers."

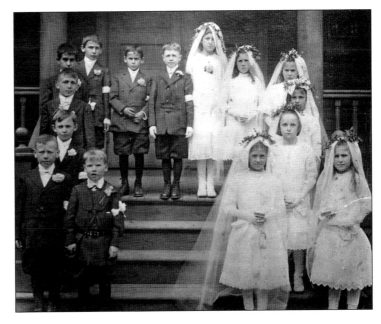

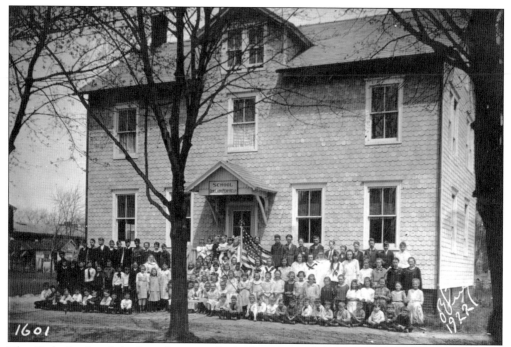

The Catholic church built its first parochial school behind the church along High Street. The school opened in September 1913 with two classrooms for 64 students. In 1920, the parish expanded its facilities by acquiring David Bendheim's former cigar factory, located on the south side of the church property. Nicknamed the "Cigar Box," there were three classrooms on the first floor. The second floor was occupied by a maintenance person and family.

On September 19, 1926, the Methodist Episcopal congregation of Lindenhurst held its first service at St. John's Church, and 99 people joined the new parish. It adopted the name Grace Methodist Episcopal Church in 1930. Rev. Barton Bovee laid the cornerstone for the church at Liberty and Wellwood Avenues on July 13, 1931. The $30,000 church, with school rooms, a social hall, and two bowling alleys, was formally dedicated on December 6, 1931.

Nine

GETTING AROUND TOWN
LOCAL TRANSPORTATION

School Street Looking South, Lindenhurst, N. Y.

The South Side Railroad arrived through future Breslau in October 1867. By 1869, the railroad acknowledged a station identified as Wellwood in its timetables. A new depot was built for Breslau, and the original Wellwood depot was moved to School Street. Shown as a private residence, the old depot has had a long life, used as a school, a fire department, and occupied by the soda-producing Sheide family.

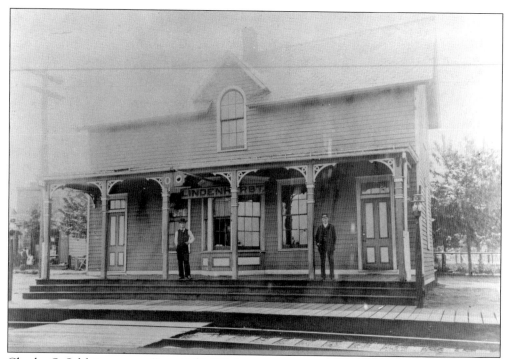

Charles S. Schleier reportedly paid $2,300 for construction of a new Breslau depot (above) in 1870. The depot also operated as the telegraph and post office. Around 1876, the Long Island Rail Road (LIRR) acquired the railroad line. An early morning blaze destroyed the charming depot on January 22, 1901. A ticket case, two record books, and a typewriter were rescued, but everything else was destroyed. Within two weeks of the fire, the LIRR started shipping lumber and materials for the construction of a new depot (below). On February 23, 1901, the *Signal* assured, "The railroad company's carpenters, under the leadership of Foreman A.S. Haff, Jr. are hustling work on the new depot, which occupies the site of the old one. It is now in frame, and will be ready for occupancy in a fortnight. It will be a neat-looking structure."

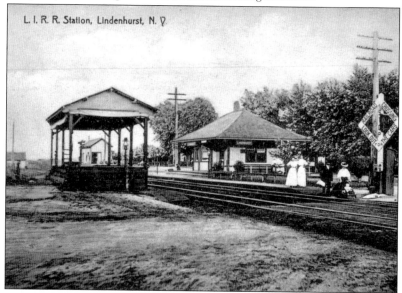

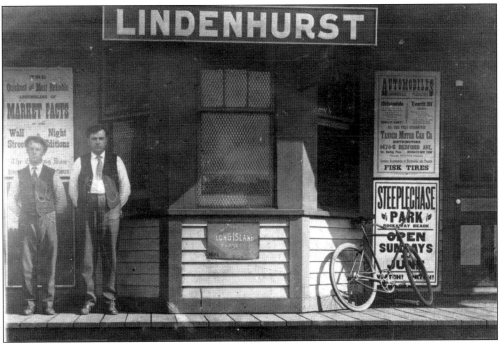

The *Signal* printed weekly construction updates. On March 2, "It is a pretty little structure, with low, broad eaves and a cone-shaped, pagoda-like roof." On March 9, "Lindenhurst will have the prettiest depot between Massapequa and Oakdale—barring none. Some are bigger, but there are none as pretty from an architectural standpoint." On March 16, painters began their work, and "carpenters are hurrying up what remains of their work." On March 23, "Station Agent Bingham is daily expecting orders to vacate his four-wheeled headquarters and take possession of the new depot . . . freight house has been moved east eighty feet." On March 30, the *Signal* declared, "The new depot was used on Monday [March 25] for the first [time]. There is as yet a conspicuous lack of seats, but that difficulty will be overcome in a few days, no doubt. Otherwise the depot is pronounced O.K."

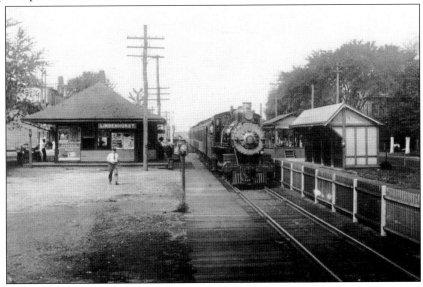

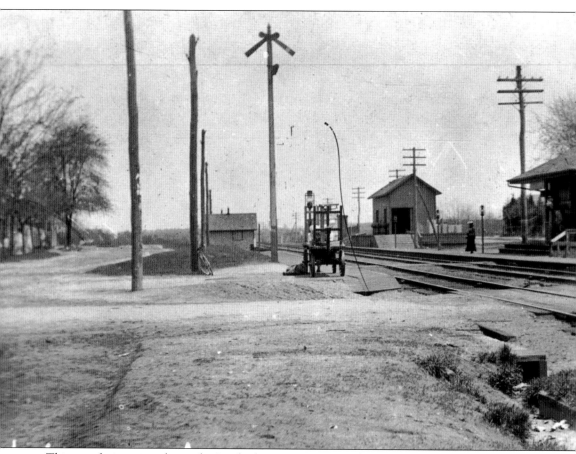

This east-facing view shows the Lindenhurst station around 1905. By 1915, a rail branch was extended a few hundred feet to the Dittmann Bros. coal yard on the north side of the tracks, and another branch reached the Vulcanite Manufacturing plant on the south side of the tracks. The depot built in 1901 welcomed visitors to Lindenhurst for several decades, from horse-and-buggy days through the advent of automobiles and into the 1960s. It was a familiar landmark for generations of residents at the southeast corner of Wellwood and Hoffman Avenues as the surrounding downtown expanded. By the mid-1960s, the LIRR decided to elevate the tracks. Desiring to preserve an important piece of local history, the Lindenhurst Historical Society petitioned the Metropolitan Transit Authority (MTA) to give it the depot and freight house rather than having them demolished. On October 25, 1968, the MTA transferred the buildings to the historical society, and they were moved to Irmisch Triangle on South Broadway. The buildings were restored as a museum, which is open during the summer months.

Lindenhurst Estates, Long Island

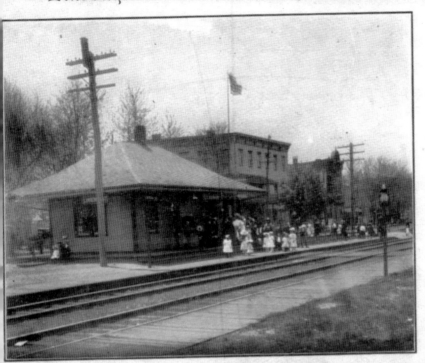

DEPOT, HOTEL AND BANK BUILDING. ABOUT 1908

INCORPORATED IN THE STATE OF NEW YORK. CAPITAL $1,000,000

DIRECTORS

LOUIS J. JURGENS. ASSISTANT TO TREAS. AND MANAGER N. Y. & LINDENHURST ESTATES CO

CHARLES A. JURGENS. CENTRAL STAMPING CO

JOSEPH E. STONE. SEC. N. Y. AND LINDENHURST EST. CO

WM. HOBSON BURROUGHS. PREST & MGR N. Y. & L. ESTATES CO

W. W. TRACY. TRACY & CO., BANKERS

GEORGE W. ADAMS. TREAS.-CASHIER. ORIENTAL BANK

HERMAN OTTENBERG. PRES. ARVERNE REALTY AND CON. CO

MARK ROSENTHAL. VICE-PRES. N. Y. & L. ESTATES CO

74 BROADWAY, N. Y.

TELEPHONE 2053 RECTOR

This postcard advertises the Lindenhurst Estates real estate development. The company chartered a series of 1907 railroad excursions from New York City for thousands of prospective buyers. Free excursion tickets were available with a reservation. Developers declared "Lindenhurst is an Industrial, Commercial and Home City, entirely independent and self sustaining." The community was suitable to build "Homes for the Mechanic and Millionaire." Lots and "villa sites" were offered as low as $75, with a $5 down payment and $3 monthly payments. An oversized ad in the *Brooklyn Daily Eagle* hyped local amenities, including two miles of frontage on the Great South Bay and Atlantic Ocean, two LIRR lines, and 28 factories producing lace, millinery goods, mechanical toys, and cigars, and "Feller's Famous Lindenhurst Brewery," which "give employment to the present population and many from nearby towns." It was also described that low rates encouraged many Lindenhurst residents to commute to New York City for business and asserted that "more people commute to Lindenhurst for employment in our factories than go to the Greater City from Lindenhurst."

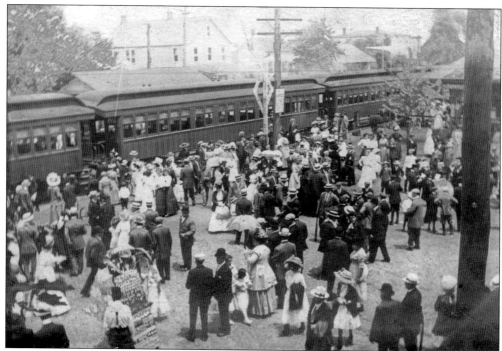

Pfingst Monday, or Pfingsten, is the German Pentecost and is widely celebrated by German American immigrants. In 1883, the *Brooklyn Daily Eagle* declared, "The jolliest day of all the year with the Germans is Pfingst Monday," likening it to "St. Patrick's day among the Irish." Yearly celebrations of Pfingst Monday, and later Pfingst Sunday as well, brought excursion trains of visitors from New York City who were met at the depot by a festive German band, and business areas were decorated with tree branches and pine boughs. Pfingsten was locally celebrated for more than four decades. In 1917, a movement to abolish the German celebration spread through the community. The festival had attracted an undesirable hoodlum element, and many in the community became uncomfortable adhering to German customs as World War I raged in Europe and more non-Germans moved to Lindenhurst.

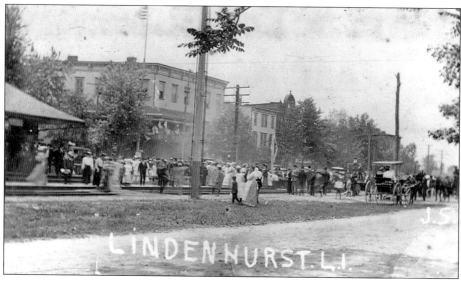

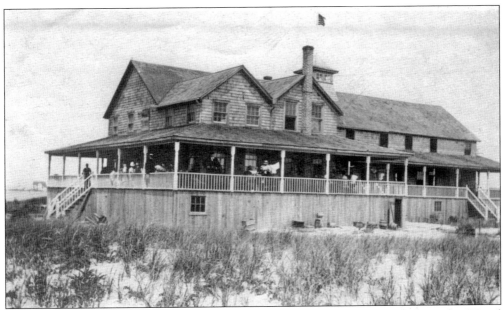

Wessel's Hotel was built in 1913 at Linden Beach, now Gilgo State Park. Proprietor John Wessel advertised "An Ideal Beach Resort . . . A short sail from Babylon and Lindenhurst, Accommodations by the day, week or season, . . . Excellent ferry service Sundays and holidays from Lindenhurst—Captains James and Charles Reve." The Reve brothers' service to Linden Beach included the powerboats *Barney C.* and *Surprise.* A round trip to Linden Beach was 25¢.

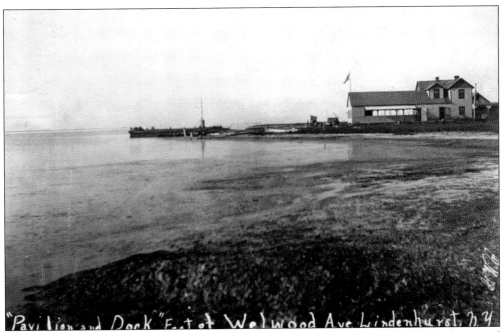

The Wellwood Avenue pavilion and dock are pictured around 1905. In 1916, the *Signal* reported a successful fishing trip: "George B. Long and little Johnnie M., of New York, enjoyed several days fishing on the bay last week piloted by Captain Singraf, who found plenty of fish. They caught 500, 450 and 300, on three successive days, shipping them to their friends along Broadway."

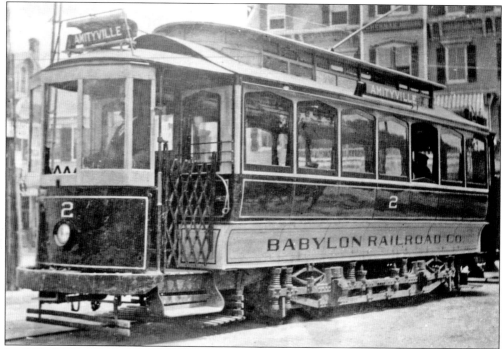

In 1909, the South Shore Traction Company purchased an old Babylon village trolley route and extended it six miles west through Lindenhurst to Amityville. Operating under the name Babylon Railroad, the electrified trolley line opened on June 11, 1910, with five small trolley cars, each with a capacity of 28 passengers. Trolley cars operated at an average of one per hour. (Courtesy of the Village of Babylon Historical and Preservation Society.)

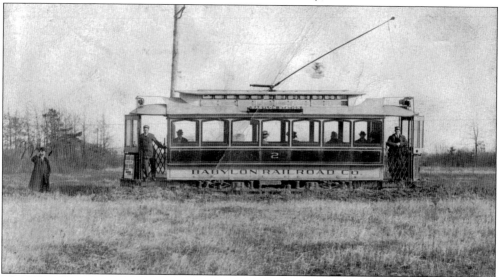

The full trolley trip from Babylon to Amityville cost 10¢ and took about 35 minutes. Intermediate trips from Lindenhurst cost just 5¢. Stories of trolley mishaps abound. Motorman Henry Ellis Willmont recalled that the trolley "used to jump off quite a bit and we'd have to run it back on." Sometimes, passengers helped to lift the car back on the tracks. (Courtesy of the Village of Babylon Historical and Preservation Society.)

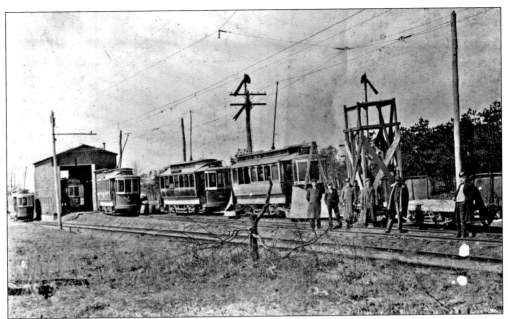

A car barn for trolley storage was located to the east at Belmont Junction, near Great East Neck Road. The trolley business was never a profitable enterprise. Despite its decade-long service shuttling residents and visitors through Lindenhurst the trolley business could not compete with the increased use of personal automobiles. On May 15, 1920, the operations of the Babylon Railroad ended. (Courtesy of the Village of Babylon Historical and Preservation Society.)

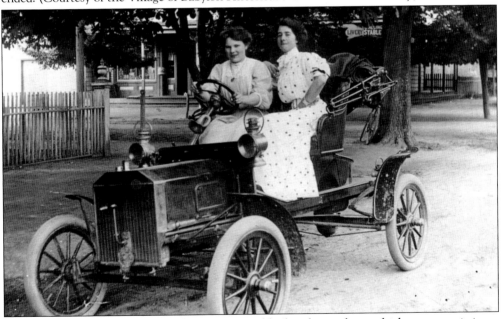

One of Lindenhurst's first automobiles was owned by hotelier and town highway commissioner John Griebel, a 1908 Ford Model S Runabout that cost about $825. It is pictured with Griebel's daughters Lily (at the right-side steering controls) and Agnes. Highlighting some of the hazards of early automobile ownership, the *Signal* reported, "Tony Warta, while cranking his automobile on Wednesday, was struck by the handle and sustained a fracture of the left arm."

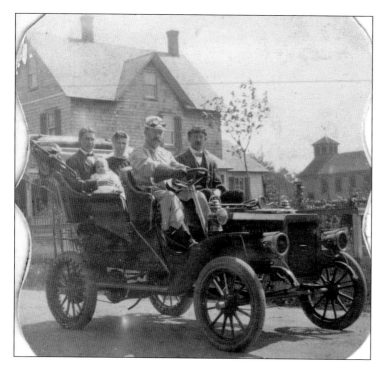

Another early automobile was that of Charles Weierter Jr., pictured at the wheel of his E-M-F Company motorcar around 1910. The increase of automobile use brought many local concerns. At a Babylon Town Board meeting, town clerk Fred Sheide proposed installation of an "arc light," or street lamp, at the intersection of Wellwood Avenue and Montauk Highway, citing the hazards of crossing the main thoroughfare after dark, as reported in the *Signal* on July 2, 1910.

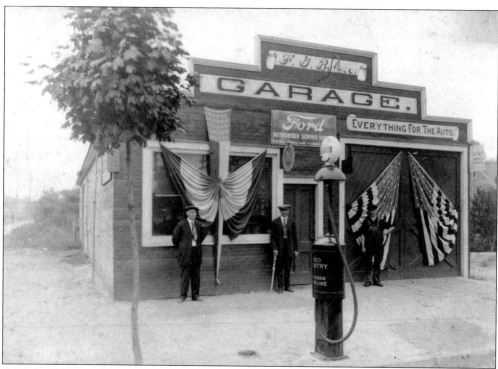

On July 19, 1912, the *Signal* announced that Fred G. Bohne's Hoffmann Avenue bicycle shop and auto garage was open for business daily. Machinist Bohne also overhauled motorcycles and motorboats and was a sales agent for the E-M-F 30 and Flanders 20 roadster automobiles.

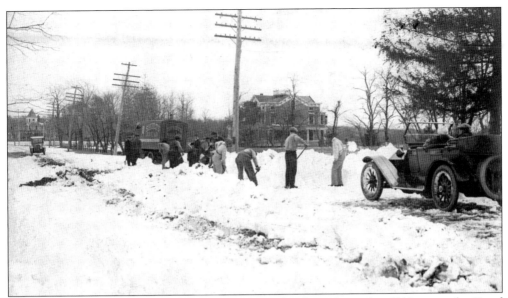

Workers clear snow from Montauk Highway by hand. After a December 1910 storm, the *Signal* headlined, "Heavy Fall of Snow Reminds Us of the Good Old Days When Sleighs Were Commoner Than Autos." The paper further described the amusement of seeing "daring automobile drivers pushing their cars through the heavy snow . . . every once in a while [they] had to get out and shovel the snow away from the wheels in order to get a start."

On August 19, 1924, a biplane crashed in a field near Montauk Highway. The *Suffolk County News* reported, "Near-by, the running team of the Lindenhurst Fire Department was practicing for the tournament . . . and saw the plane descent but thought it was maneuvering to get closer to them. When they saw the crash, however, they ran up and extinguished the fire with chemicals, pulling the three men out." Two survived.

BIBLIOGRAPHY

Atlas of Long Island, New York. New York, NY: Beers, Comstock & Cline, 1873.

Babylon Leader, 1921–1934.

Babylon Town Leader, August 27, 1959.

Bayles, Richard M. *History of Suffolk County, New York, with Illustrations, Portraits, and Sketches of Prominent Families and Individuals.* New York, NY: W.W. Munsell and Company, 1882.

Brooklyn Daily Eagle, 1868–1932.

Frevert, Lorena M. "Breslau's First Thirty Years, Parts I-VI." *Long Island Forum,* November 1945–April 1946.

F.W. Beers & Co. *Atlas of the Towns of Babylon, Islip, and South Part of Brookhaven in Suffolk Co., N.Y.* New York, NY: Wendelken & Co., 1888.

Homes on the South Side Railroad of Long Island—For New York Business Men. Brooklyn, NY: South Side Rail Road Company of Long Island, 1873.

Hyde, Merritt B. *Atlas of a Part of Suffolk County, Long Island, New York: South Side–Ocean Shore: Complete in Two Volumes: Based upon Actual Measurements by Our Own Corps of Engineers, Maps on File at County Offices, Also Maps from Actual Surveys Furnished by Surveyors and Individual Owners.* New York, NY: E. Belcher Hyde, 1915.

Lindenhurst News, October 17, 1908.

Lindenhurst Star, 1927–1958.

New York Times, May 25, 1924.

Newsday, May 20, 1946.

South Side Signal, 1870–1920.

Suffolk County News, August 22, 1924.

ABOUT THE AUTHORS

The Lindenhurst Historical Society was formed in 1948 and dedicated the local history museum in 1958, offering visitors a glimpse into the village's past, from Breslau industries and hotels through the post–World War II suburban boom. The historical society operates a historic home museum at 272 South Wellwood Avenue and the restored 1901 railroad depot and freight house at Irmisch Park on Broadway in Lindenhurst.

Anna Jaeger (Lindenhurst High School class of 1961) is the historian for the village of Lindenhurst and a lifelong resident. Her ancestors have lived in Lindenhurst for three generations. She taught in the Lindenhurst School District for 33 years at William Rall Elementary School and is active in St. John's Lutheran Church, the Lindenhurst Rotary Club, and the Retired Teachers Association of Lindenhurst.

Mary Cascone (Lindenhurst High School class of 1989) is the historian for the town of Babylon and manages the Town of Babylon History Museum, opened in 2010 with exhibits pertaining to the entire town of Babylon, including Amityville, Babylon village, Copiague, Deer Park, East Farmingdale, Lindenhurst, North Amityville, North Babylon, North Lindenhurst, West Babylon, Wheatley Heights, Wyandanch, and the barrier beach communities of Captree Island, Gilgo Beach, West Gilgo, Oak Beach, and Oak Island. The Town of Babylon History Museum is located in the Old Town Hall, 47 West Main Street, Babylon.

DISCOVER THOUSANDS OF LOCAL HISTORY BOOKS FEATURING MILLIONS OF VINTAGE IMAGES

Arcadia Publishing, the leading local history publisher in the United States, is committed to making history accessible and meaningful through publishing books that celebrate and preserve the heritage of America's people and places.

Find more books like this at
www.arcadiapublishing.com

Search for your hometown history, your old stomping grounds, and even your favorite sports team.

Consistent with our mission to preserve history on a local level, this book was printed in South Carolina on American-made paper and manufactured entirely in the United States. Products carrying the accredited Forest Stewardship Council (FSC) label are printed on 100 percent FSC-certified paper.

MADE IN THE USA